YEAR PLANNER

GW00514916

SEPTEMPER

WEEK 36	
1	Mo
2	Tu
3	We ◐
4	Th
5	Fr
6	Sa
7	Su
WEEK 37	
8	Mo
9	Tu
10	We ○
11	Th
12	Fr
13	Sa
14	Su
WEEK 38	
15	Mo
16	Tu
17	We
18	Th ◑
19	Fr
20	Sa
21	Su
WEEK 39	
22	Mo
23	Tu
24	We
25	Th
26	Fr ●
27	Sa
28	Su
WEEK 40	
29	Mo
30	Tu

OCTOBER

1	We
2	Th ◐
3	Fr
4	Sa
5	Su
WEEK 41	
6	Mo
7	Tu
8	We
9	Th
10	Fr ○
11	Sa
12	Su
WEEK 42	
13	Mo
14	Tu
15	We
16	Th
17	Fr
18	Sa ◑
19	Su
WEEK 43	
20	Mo
21	Tu
22	We
23	Th
24	Fr
25	Sa ●
26	Su
WEEK 44	
27	Mo
28	Tu
29	We
30	Th
31	Fr

NOVEMBER

1	Sa ◐
2	Su
WEEK 45	
3	Mo
4	Tu
5	We
6	Th
7	Fr
8	Sa
9	Su ○
WEEK 46	
10	Mo
11	Tu
12	We
13	Th
14	Fr
15	Sa
16	Su
WEEK 47	
17	Mo ◑
18	Tu
19	We
20	Th
21	Fr
22	Sa
23	Su ●
WEEK 48	
24	Mo
25	Tu
26	We
27	Th
28	Fr
29	Sa
30	Su ◐

DECEMBER

WEEK 49	
1	Mo
2	Tu
3	We
4	Th
5	Fr
6	Sa
7	Su
WEEK 50	
8	Mo ○
9	Tu
10	We
11	Th
12	Fr
13	Sa
14	Su
WEEK 51	
15	Mo
16	Tu ◑
17	We
18	Th
19	Fr
20	Sa
21	Su
WEEK 52	
22	Mo
23	Tu ●
24	We
25	Th
26	Fr
27	Sa
28	Su
WEEK 1	
29	Mo
30	Tu ◐
31	We

01–04.2004

JANUARY	FEBRUARY	MARCH	APRIL
WEEK 1	1 Su	**WEEK 10**	1 Th
1 Th	**WEEK 6**	1 Mo	2 Fr
2 Fr	2 Mo	2 Tu	3 Sa
3 Sa	3 Tu	3 We	4 Su
4 Su	4 We	4 Th	**WEEK 15**
WEEK 2	5 Th	5 Fr	5 Mo ○
5 Mo	6 Fr ○	6 Sa	6 Tu
6 Tu	7 Sa	7 Su ○	7 We
7 We ○	8 Su	**WEEK 11**	8 Th
8 Th	**WEEK 7**	8 Mo	9 Fr
9 Fr	9 Mo	9 Tu	10 Sa
10 Sa	10 Tu	10 We	11 Su
11 Su	11 We	11 Th	**WEEK 16**
WEEK 3	12 Th	12 Fr	12 Mo ◐
12 Mo	13 Fr ◐	13 Sa ◐	13 Tu
13 Tu	14 Sa	14 Su	14 We
14 We	15 Su	**WEEK 12**	15 Th
15 Th ◐	**WEEK 8**	15 Mo	16 Fr
16 Fr	16 Mo	16 Tu	17 Sa
17 Sa	17 Tu	17 We	18 Su
18 Su	18 We	18 Th	**WEEK 17**
WEEK 4	19 Th	19 Fr	19 Mo ●
19 Mo	20 Fr ●	20 Sa ●	20 Tu
20 Tu	21 Sa	21 Su	21 We
21 We ●	22 Su	**WEEK 13**	22 Th
22 Th	**WEEK 9**	22 Mo	23 Fr
23 Fr	23 Mo	23 Tu	24 Sa
24 Sa	24 Tu	24 We	25 Su
25 Su	25 We	25 Th	**WEEK 18**
WEEK 5	26 Th	26 Fr	26 Mo
26 Mo	27 Fr	27 Sa	27 Tu ◑
27 Tu	28 Sa ◑	28 Su	28 We
28 We	29 Su	**WEEK 14**	29 Th
29 Th ◑		29 Mo ◑	30 Fr
30 Fr		30 Tu	
31 Sa		31 We	

05–08.2004

MAY

1 Sa
2 Su

WEEK 19

3 Mo
4 Tu ○
5 We
6 Th
7 Fr
8 Sa
9 Su

WEEK 20

10 Mo
11 Tu ◗
12 We
13 Th
14 Fr
15 Sa
16 Su

WEEK 21

17 Mo
18 Tu
19 We ●
20 Th
21 Fr
22 Sa
23 Su

WEEK 22

24 Mo
25 Tu
26 We
27 Th ◖
28 Fr
29 Sa
30 Su

WEEK 23

31 Mo

JUNE

1 Tu
2 We
3 Th ○
4 Fr
5 Sa
6 Su

WEEK 24

7 Mo
8 Tu
9 We ◗
10 Th
11 Fr
12 Sa
13 Su

WEEK 25

14 Mo
15 Tu
16 We
17 Th ●
18 Fr
19 Sa
20 Su

WEEK 26

21 Mo
22 Tu
23 We
24 Th
25 Fr ◖
26 Sa
27 Su

WEEK 27

28 Mo
29 Tu
30 We

JULY

1 Th
2 Fr ○
3 Sa
4 Su

WEEK 28

5 Mo
6 Tu
7 We
8 Th
9 Fr ◗
10 Sa
11 Su

WEEK 29

12 Mo
13 Tu
14 We
15 Th
16 Fr
17 Sa ●
18 Su

WEEK 30

19 Mo
20 Tu
21 We
22 Th
23 Fr
24 Sa
25 Su ◖

WEEK 31

26 Mo
27 Tu
28 We
29 Th
30 Fr
31 Sa ○

AUGUST

1 Su

WEEK 32

2 Mo
3 Tu
4 We
5 Th
6 Fr
7 Sa ◗

8 Su

WEEK 33

9 Mo
10 Tu
11 We
12 Th
13 Fr
14 Sa
15 Su

WEEK 34

16 Mo ●
17 Tu
18 We
19 Th
20 Fr
21 Sa
22 Su

WEEK 35

23 Mo ◖
24 Tu
25 We
26 Th
27 Fr
28 Sa
29 Su

Week 36

30 Mo ○
31 Tu

09–12.2004

SEPTEMBER	OCTOBER	NOVEMBER	DECEMBER
1 We	1 Fr	**WEEK 45**	1 We
2 Th	2 Sa	1 Mo	2 Th
3 Fr	3 Su	2 Tu	3 Fr
4 Sa	**WEEK 41**	3 We	4 Sa
5 Su	4 Mo	4 Th	5 Su ◐
WEEK 37	5 Tu	5 Fr ◐	**WEEK 50**
6 Mo ◐	6 We ◐	6 Sa	6 Mo
7 Tu	7 Th	7 Su	7 Tu
8 We	8 Fr	**WEEK 46**	8 We
9 Th	9 Sa	8 Mo	9 Th
10 Fr	10 Su	9 Tu	10 Fr
11 Sa	**WEEK 42**	10 We	11 Sa
12 Su	11 Mo	11 Th	12 Su ●
WEEK 38	12 Tu	12 Fr ●	**WEEK 51**
13 Mo	13 We	13 Sa	13 Mo
14 Tu ●	14 Th ●	14 Su	14 Tu
15 We	15 Fr	**WEEK 47**	15 We
16 Th	16 Sa	15 Mo	16 Th
17 Fr	17 Su	16 Tu	17 Fr
18 Sa	**WEEK 43**	17 We	18 Sa ◑
19 Su	18 Mo	18 Th	19 Su
WEEK 39	19 Tu	19 Fr ◑	**WEEK 52**
20 Mo	20 We ◑	20 Sa	20 Mo
21 Tu ◑	21 Th	21 Su	21 Tu
22 We	22 Fr	**WEEK 48**	22 We
23 Th	23 Sa	22 Mo	23 Th
24 Fr	24 Su	23 Tu	24 Fr
25 Sa	**WEEK 44**	24 We	25 Sa
26 Su	25 Mo	25 Th	26 Su ○
WEEK 40	26 Tu	26 Fr ○	**WEEK 53**
27 Mo	27 We	27 Sa	27 Mo
28 Tu ○	28 Th ○	28 Su	28 Tu
29 We	29 Fr	**WEEK 49**	29 We
30 Th	30 Sa	29 Mo	30 Th
	31 Su	30 Tu	31 Fr

CREDITS

p. 4: **To Have (Fascinating Figures)**
1951. Oil on canvas, 76 x 61 cm

Week 1: **A-Cute Injury**
1953. Oil on canvas, 76 x 61 cm

Week 2: **Now Don't Ask Me
"What's Cookin'"**
1948. Oil on canvas, 76 x 61 cm

Week 3: **The Finishing Touch**
1960. Oil on canvas, 76 x 61 cm

Week 4: **No You Don't!**
1956. Oil on canvas, 76 x 61 cm

Week 5: **A Refreshing Lift**
1970. Oil on canvas, 76 x 61 cm

Week 6: **Let's Eat Out**
1967. Oil on canvas, 76 x 61 cm

Week 7: **Mona (Heartwarming)**
1959. Oil on canvas, 76 x 61 cm

Week 8: **Thar She Blows**
1939. Oil on canvas, 71 x 56 cm

Week 9: **Weighty Problem
(Starting at the Bottom)**
1962. Oil on canvas, 76 x 61 cm

Week 10: **Riding High**
1958. Oil on canvas, 76 x 61 cm

Week 11: **Skirts Ahoy!**
1967. Oil on canvas, 76 x 61 cm

Week 12: **This Doesn't Seem to
Keep the Chap from My Lips**
1948. Oil on canvas, 76 x 61 cm

Week 13: **I Gave Him the Brush-Off
(I Gave This the Brush-Off)**
1947. Oil on canvas, 76 x 61 cm

Week 14: **The Wrong Nail
(Wrong Nail)**
1967. Oil on canvas, 76 x 61 cm

Week 15: **Eye Catcher**
1969. Oil on canvas, 76 x 61 cm

Week 16: **Haven't I Got Swell Eggs?**
1946. Oil on canvas, 76 x 61 cm

Week 17: **I've Been Spotted**
1949. Oil on canvas, 76 x 61 cm

Week 18: **On the Fence**
1959. Oil on canvas, 76 x 61 cm

Week 19: **Cold Feed (Cold Front)**
1958. Oil on canvas, 76 x 61 cm

Week 20: **Pleasant to Sí**
1969. Oil on canvas, 76 x 61 cm

Week 21: **Perfect Form**
1968. Oil on canvas, 76 x 61 cm

Week 22: **Worth Cultivating
(A Nice Crop)**
1952. Oil on canvas, 76 x 61 cm

Week 23: **Second Thoughts**
1969. Oil on canvas, 76 x 61 cm

Week 24: **Red, White, and Blue
(Red, Hot, and Blue)**
1966. Oil on canvas, 76 x 61 cm

Week 25: **NAPA advertisement**
undated. Oil on canvas, 91 x 81 cm

Week 26: **A Near Miss
(Surprising Turn)**
1960. Oil on canvas, 76 x 61 cm

Week 27: **Hi-Ho, Sliver!**
1969. Oil on canvas, 76 x 61 cm

Week 28: **Smoke Screen**
1958. Oil on canvas, 76 x 61 cm

Week 29: **A Fast Takeoff
(A Speedy Takeoff)**
1954. Oil on canvas, 76 x 61 cm

Week 30: **Shell Game
(Shell-Shocked)**
1959. Oil on canvas, 76 x 61 cm

Week 31: **Sailor Beware**
1953. Oil on canvas, 76 x 61 cm

Week 32: **Partial Coverage
(Flashback; Sunnyside Up)**
1960. Oil on canvas, 76 x 61 cm

Week 33: **Hold Everything
(Skirting the Issue)**
1962. Oil on canvas, 76 x 61 cm

Week 34: **Aiming to Please
(Shoving Off)**
1960. Oil on canvas, 76 x 61 cm

Week 35: **Just for You**
1961. Oil on canvas, 76 x 61 cm

Week 36: **Hairline Decision
(Dis-Tressing)**
1962. Oil on canvas, 76 x 61 cm

Week 37: **One for the Money**
1954. Oil on canvas, 76 x 61 cm

Week 38: **Wish You Were Near**
1969. Oil on canvas, 76 x 61 cm

Week 39: **Socking It Away
(This Way I Draw More Interest);
(Investments Should Be ...)**
1949. Oil on canvas, 76 x 61 cm

Week 40: **I Run into the Most
Interesting People**
1948. Oil on canvas, 76 x 61 cm

Week 41: **Aiming High
(Will William Tell?)**
1959. Oil on canvas, 76 x 61 cm

Week 42: **He Thinks I'm Too Good
to Be True (She sits home every night,
just waiting there for you. She's per-
fect ... yes, but possibly she's too
good to be true)**
1947. Oil on canvas, 76 x 61 cm

Week 43: **Fresh!**
1949. Oil on canvas, 76 x 61 cm

Week 44: **Sheer Delight
(This Soots Me)**
1948. Oil on canvas, 76 x 61 cm

Week 45: **I'm Not Shy, I'm Just Retiring
(Too Much Champagne)**
1947. Oil on canvas, 76 x 61 cm

Week 46: **Jeepers, Peepers (Jeepers
Creepers)**
1948. Oil on canvas, 76 x 61 cm

Week 47: **Bear Facts
(Bearback Rider)**
1962. Oil on canvas, 76 x 61 cm

Week 48: **A Warm Welcome**
1959. Oil on canvas, 76 x 61 cm

Week 49: **Surprising Catch**
1952. Oil on canvas, 76 x 61 cm

Week 50: **Charmaine**
1957. Oil on canvas, 76 x 61 cm

Week 51: **Who, Me? (Hard to Suit)**
1952. Oil on canvas, 76 x 61 cm

Week 52: **A Christmas Eve
(Waiting for Santa)**
1954. Oil on canvas, 76 x 61 cm

Week 53: **Looking for Trouble**
1953. Oil on canvas, 76 x 61 cm

Last page: **Peek-a-View**
1940. Oil on canvas, 71 x 56 cm

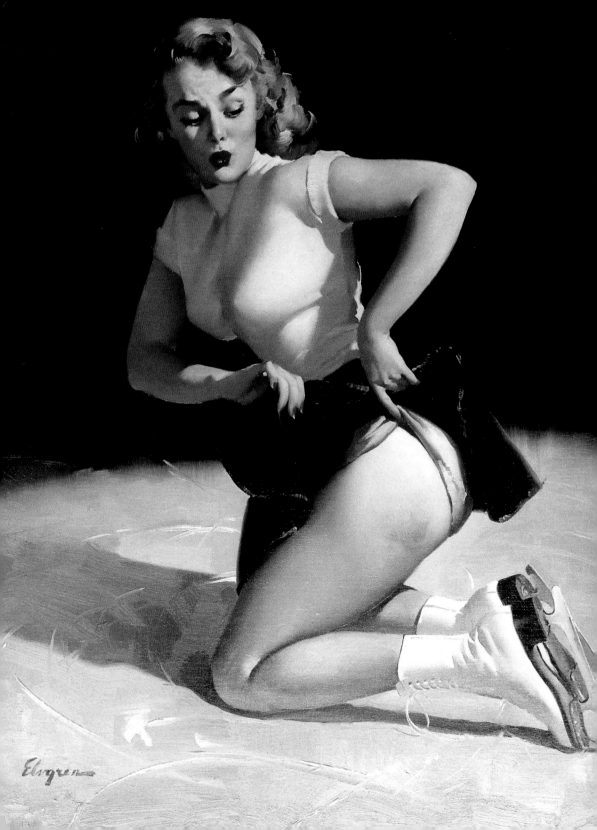

Monday	29	5	12	19	26
Tuesday	30	6	13	20	27
Wednesday	31	7	14	21	28
Thursday	1	8	15	22	29
Friday	2	9	16	23	30
Saturday	3	10	17	24	31
Sunday	4	11	18	25	1
WEEK	**1**	**2**	**3**	**4**	**5**

Monday Montag Lundi Lunes Lunedì Segunda-feira Maandag 月

29

Tuesday Dienstag Mardi Martes Martedì Terça-feira Dinsdag 火

◑

30

Wednesday Mittwoch Mercredi Miércoles Mercoledì Quarta-feira Woensdag 水

31

Thursday Donnerstag Jeudi Jueves Giovedì Quinta-feira Donderdag 木

New Year's Day | Jour de l'An |
Nouvel An | Neujahr | Capodanno |
Nieuwjaarsdag | Año Nuevo | Ano Novo

1

Friday Freitag Vendredi Viernes Venerdì Sexta-feira Vrijdag 金

(UK) Bank Holiday (Scotland only)

2

Saturday Samstag Samedi Sábado Sabato Sábado Zaterdag 土

3

Sunday Sonntag Dimanche Domingo Domenica Domingo Zondag 日

4

2. WEEK

01.2004

Monday	5	12	19	26	2
Tuesday	6	13	20	27	3
Wednesday	7	14	21	28	4
Thursday	8	15	22	29	5
Friday	9	16	23	30	6
Saturday	10	17	24	31	7
Sunday	11	18	25	1	8
WEEK	2	3	4	5	6

Monday Montag Lundi Lunes Lunedì Segunda-feira Maandag 月

5

Tuesday Dienstag Mardi Martes Martedì Terça-feira Dinsdag 火

6

(D) Heilige Drei Könige (teilweise)
(A) (E) (I) Heilige Drei Könige |
Reyes | Epifania

Wednesday Mittwoch Mercredi Miércoles Mercoledì Quarta-feira Woensdag 水

○

7

Thursday Donnerstag Jeudi Jueves Giovedì Quinta-feira Donderdag 木

8

Friday Freitag Vendredi Viernes Venerdì Sexta-feira Vrijdag 金

9

Saturday Samstag Samedi Sábado Sabato Sábado Zaterdag 土

10

Sunday Sonntag Dimanche Domingo Domenica Domingo Zondag 日

11

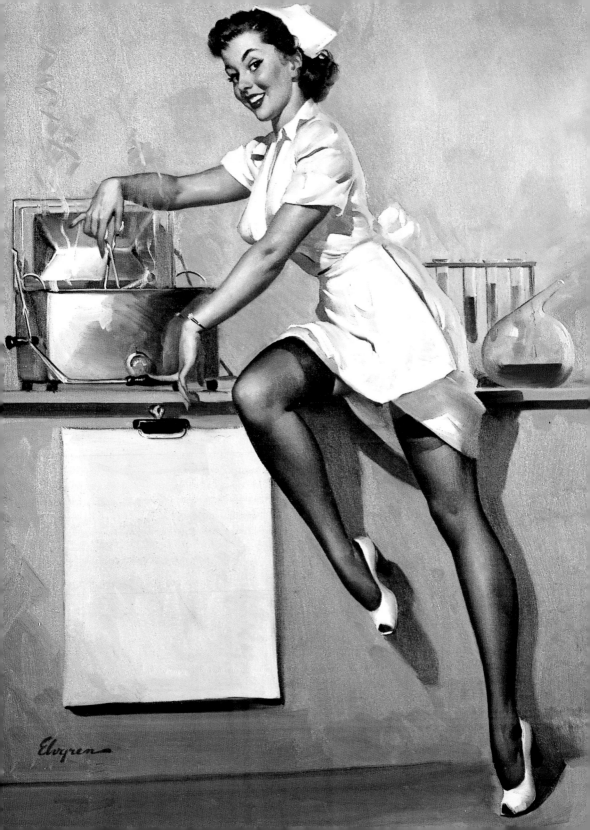

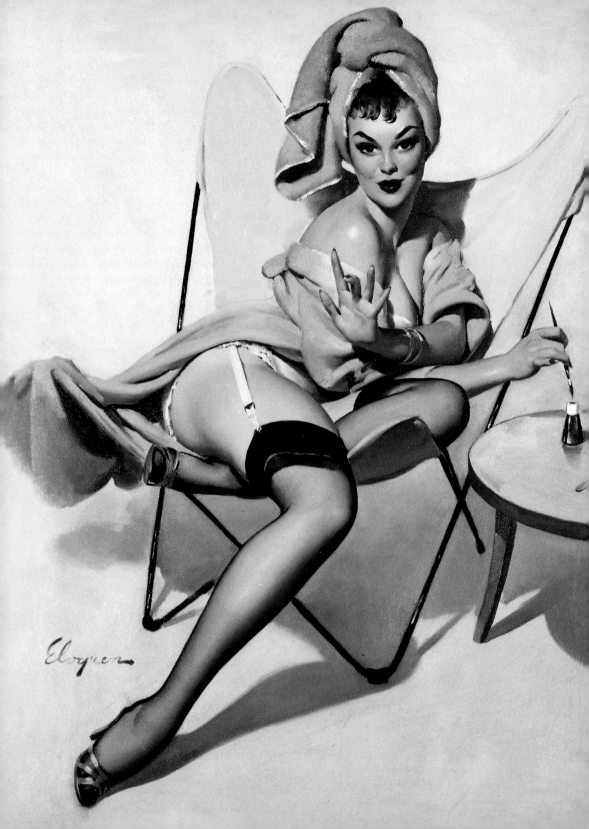

3. WEEK

01.2004

Monday	12	19	26	2	9
Tuesday	13	20	27	3	10
Wednesday	14	21	28	4	11
Thursday	15	22	29	5	12
Friday	16	23	30	6	13
Saturday	17	24	31	7	14
Sunday	18	25	1	8	15
WEEK	3	4	5	6	7

Monday Montag Lundi Lunes Lunedì Segunda-feira Maandag 月

ⓙ Coming-of-Age Day

12

Tuesday Dienstag Mardi Martes Martedì Terça-feira Dinsdag 火

13

Wednesday Mittwoch Mercredi Miércoles Mercoledì Quarta-feira Woensdag 水

14

Thursday Donnerstag Jeudi Jueves Giovedì Quinta-feira Donderdag 木

◑

15

Friday Freitag Vendredi Viernes Venerdì Sexta-feira Vrijdag 金

16

Saturday Samstag Samedi Sábado Sabato Sábado Zaterdag 土

17

Sunday Sonntag Dimanche Domingo Domenica Domingo Zondag 日

18

4. WEEK

01.2004

Monday	19	26	2	9	16
Tuesday	20	27	3	10	17
Wednesday	21	28	4	11	18
Thursday	22	29	5	12	19
Friday	23	30	6	13	20
Saturday	24	31	7	14	21
Sunday	25	1	8	15	22
WEEK	**4**	**5**	**6**	**7**	**8**

Monday Montag Lundi Lunes Lunedì Segunda-feira Maandag 月

(USA) Martin Luther King Day

19

Tuesday Dienstag Mardi Martes Martedì Terça-feira Dinsdag 火

20

Wednesday Mittwoch Mercredi Miércoles Mercoledì Quarta-feira Woensdag 水

●

21

Thursday Donnerstag Jeudi Jueves Giovedì Quinta-feira Donderdag 木

(K) Lunar New Year's Day

22

Friday Freitag Vendredi Viernes Venerdì Sexta-feira Vrijdag 金

23

Saturday Samstag Samedi Sábado Sabato Sábado Zaterdag 土

24

Sunday Sonntag Dimanche Domingo Domenica Domingo Zondag 日

25

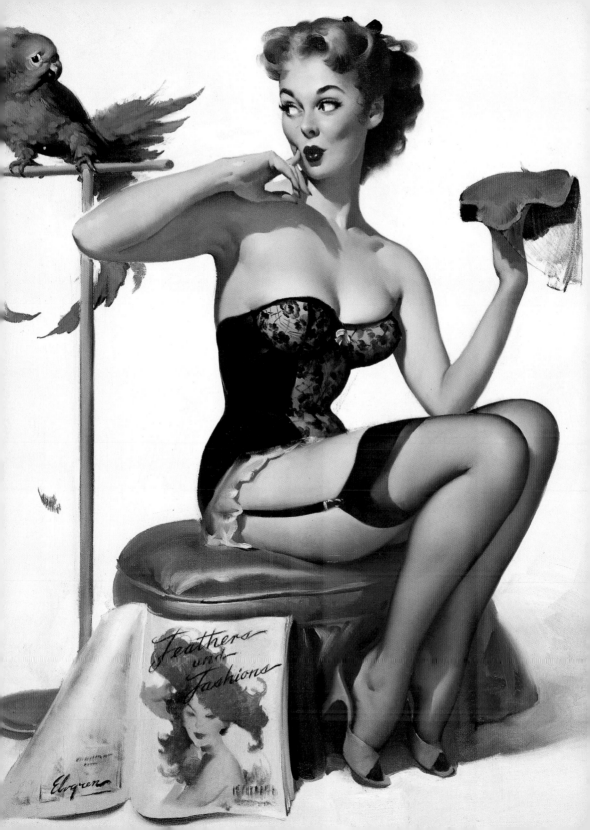

Feathers and Fashions

Elvgren

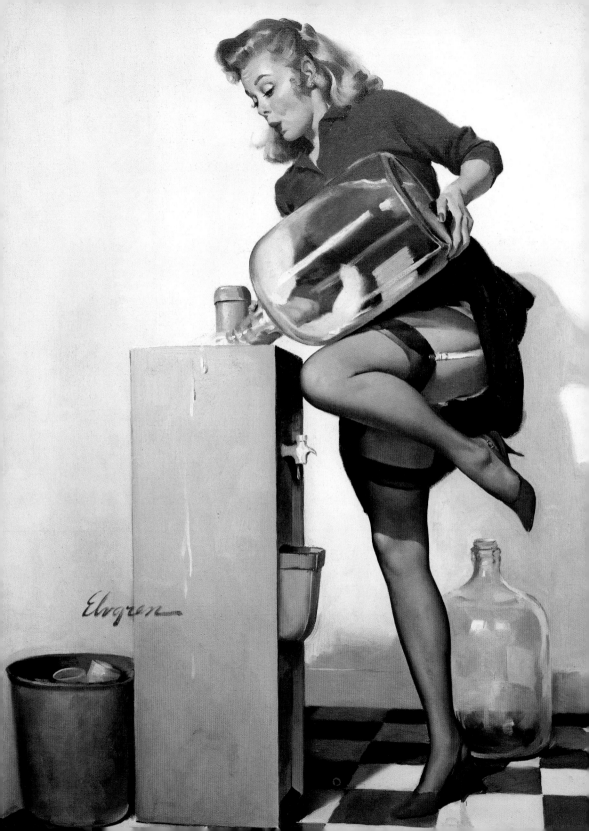

5. ■ WEEK

01|02.2004

Monday	26	2	9	16	23
Tuesday	27	3	10	17	24
Wednesday	28	4	11	18	25
Thursday	29	5	12	19	26
Friday	30	6	13	20	27
Saturday	31	7	14	21	28
Sunday	1	8	15	22	29
WEEK	**5**	**6**	**7**	**8**	**9**

Monday Montag Lundi Lunes Lunedì Segunda-feira Maandag 月

26

Tuesday Dienstag Mardi Martes Martedì Terça-feira Dinsdag 火

27

Wednesday Mittwoch Mercredi Miércoles Mercoledì Quarta-feira Woensdag 水

28

Thursday Donnerstag Jeudi Jueves Giovedì Quinta-feira Donderdag 木

◐

29

Friday Freitag Vendredi Viernes Venerdì Sexta-feira Vrijdag 金

30

Saturday Samstag Samedi Sábado Sabato Sábado Zaterdag 土

31

Sunday Sonntag Dimanche Domingo Domenica Domingo Zondag 日

1

6. ■ WEEK

Monday	2	9	16	23	1
Tuesday	3	10	17	24	2
Wednesday	4	11	18	25	3
Thursday	5	12	19	26	4
Friday	6	13	20	27	5
Saturday	7	14	21	28	6
Sunday	8	15	22	29	7
WEEK	6	7	8	9	10

Monday Montag Lundi Lunes Lunedì Segunda-feira Maandag 月

2

Tuesday Dienstag Mardi Martes Martedì Terça-feira Dinsdag 火

3

Wednesday Mittwoch Mercredi Miércoles Mercoledì Quarta-feira Woensdag 水

(IL) Tu B'Shevat

4

Thursday Donnerstag Jeudi Jueves Giovedì Quinta-feira Donderdag 木

5

Friday Freitag Vendredi Viernes Venerdì Sexta-feira Vrijdag 金

○

6

Saturday Samstag Samedi Sábado Sabato Sábado Zaterdag 土

7

Sunday Sonntag Dimanche Domingo Domenica Domingo Zondag 日

8

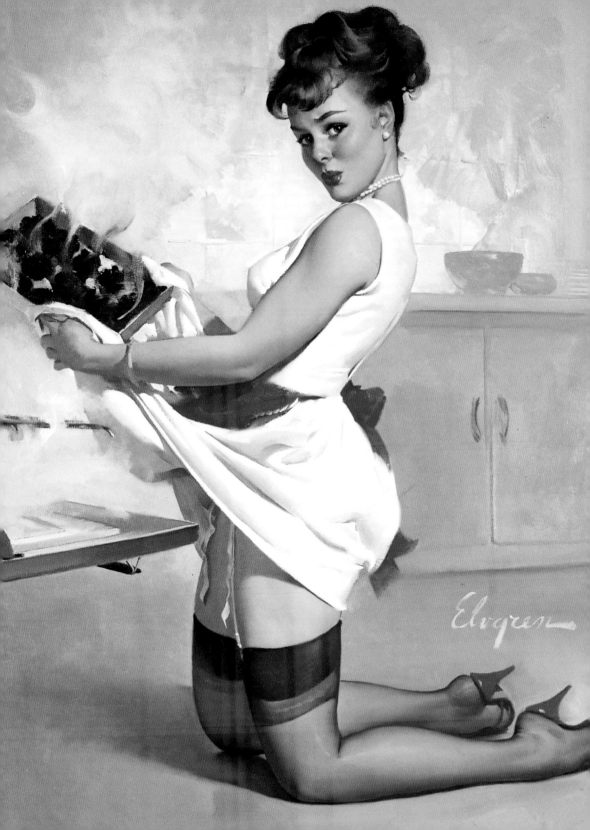

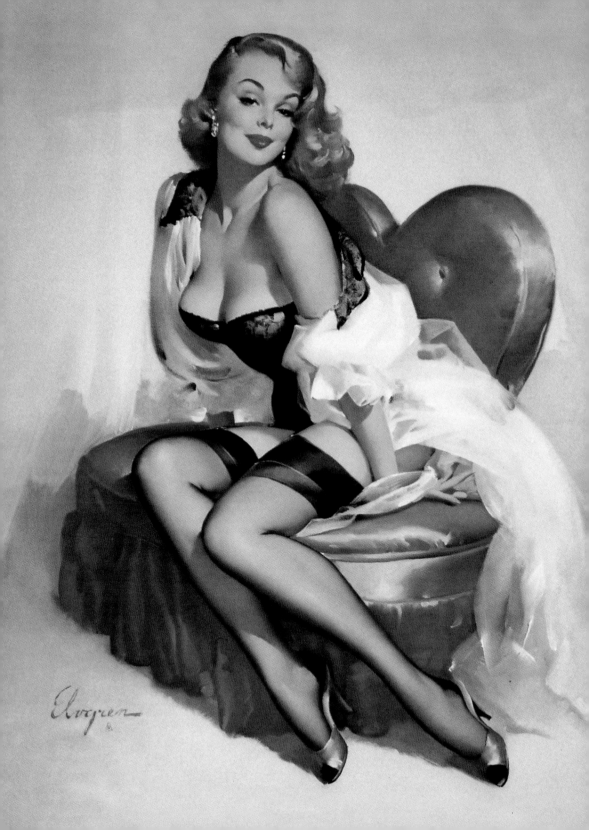

7. ■ WEEK

02.2004

Monday	9	16	23	1	8
Tuesday	10	17	24	2	9
Wednesday	11	18	25	3	10
Thursday	12	19	26	4	11
Friday	13	20	27	5	12
Saturday	14	21	28	6	13
Sunday	15	22	29	7	14
WEEK	**7**	**8**	**9**	**10**	**11**

Monday Montag Lundi Lunes Lunedì Segunda-feira Maandag 月

9

Tuesday Dienstag Mardi Martes Martedì Terça-feira Dinsdag 火

10

Wednesday Mittwoch Mercredi Miércoles Mercoledì Quarta-feira Woensdag 水

(J) Commemoration of the Founding
of the Nation

11

Thursday Donnerstag Jeudi Jueves Giovedì Quinta-feira Donderdag 木

12

Friday Freitag Vendredi Viernes Venerdì Sexta-feira Vrijdag 金

13

Saturday Samstag Samedi Sábado Sabato Sábado Zaterdag 土

14

Sunday Sonntag Dimanche Domingo Domenica Domingo Zondag 日

15

8. ■ WEEK

02.2004

Monday	16	23	1	8	15
Tuesday	17	24	2	9	16
Wednesday	18	25	3	10	17
Thursday	19	26	4	11	18
Friday	20	27	5	12	19
Saturday	21	28	6	13	20
Sunday	22	29	7	14	21
WEEK	**8**	**9**	**10**	**11**	**12**

Monday Montag Lundi Lunes Lunedì Segunda-feira Maandag 月

(USA) Presidents' Day

16

Tuesday Dienstag Mardi Martes Martedì Terça-feira Dinsdag 火

17

Wednesday Mittwoch Mercredi Miércoles Mercoledì Quarta-feira Woensdag 水

18

Thursday Donnerstag Jeudi Jueves Giovedì Quinta-feira Donderdag 木

19

Friday Freitag Vendredi Viernes Venerdì Sexta-feira Vrijdag 金

●

20

Saturday Samstag Samedi Sábado Sabato Sábado Zaterdag 土

21

Sunday Sonntag Dimanche Domingo Domenica Domingo Zondag 日

22

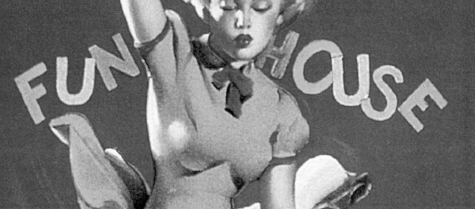

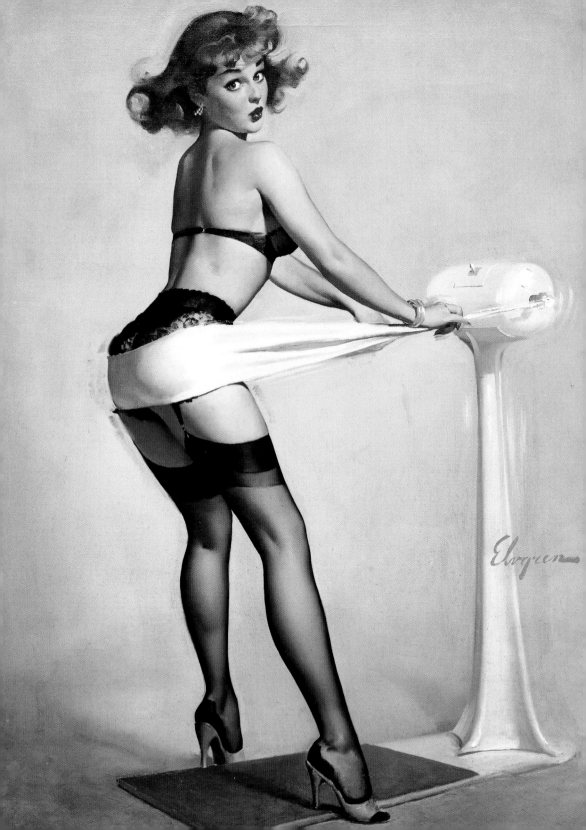

9. ■ WEEK

02.2004

Monday	23	1	8	15	22
Tuesday	24	2	9	16	23
Wednesday	25	3	10	17	24
Thursday	26	4	11	18	25
Friday	27	5	12	19	26
Saturday	28	6	13	20	27
Sunday	29	7	14	21	28
WEEK	9	10	11	12	13

Monday Montag Lundi Lunes Lunedì Segunda-feira Maandag 月

23

Tuesday Dienstag Mardi Martes Martedì Terça-feira Dinsdag 火

24

Wednesday Mittwoch Mercredi Miércoles Mercoledì Quarta-feira Woensdag 水

25

Thursday Donnerstag Jeudi Jueves Giovedì Quinta-feira Donderdag 木

26

Friday Freitag Vendredi Viernes Venerdì Sexta-feira Vrijdag 金

27

Saturday Samstag Samedi Sábado Sabato Sábado Zaterdag 土
◖

28

Sunday Sonntag Dimanche Domingo Domenica Domingo Zondag 日

29

10. WEEK

03.2004

Monday Montag Lundi Lunes Lunedì Segunda-feira Maandag 月

(K) 3-1 Anniversary

1

Tuesday Dienstag Mardi Martes Martedì Terça-feira Dinsdag 火

2

Wednesday Mittwoch Mercredi Miércoles Mercoledì Quarta-feira Woensdag 水

3

Thursday Donnerstag Jeudi Jueves Giovedì Quinta-feira Donderdag 木

4

Friday Freitag Vendredi Viernes Venerdì Sexta-feira Vrijdag 金

5

Saturday Samstag Samedi Sábado Sabato Sábado Zaterdag 土

6

Sunday Sonntag Dimanche Domingo Domenica Domingo Zondag 日

○ (IL) Purim

7

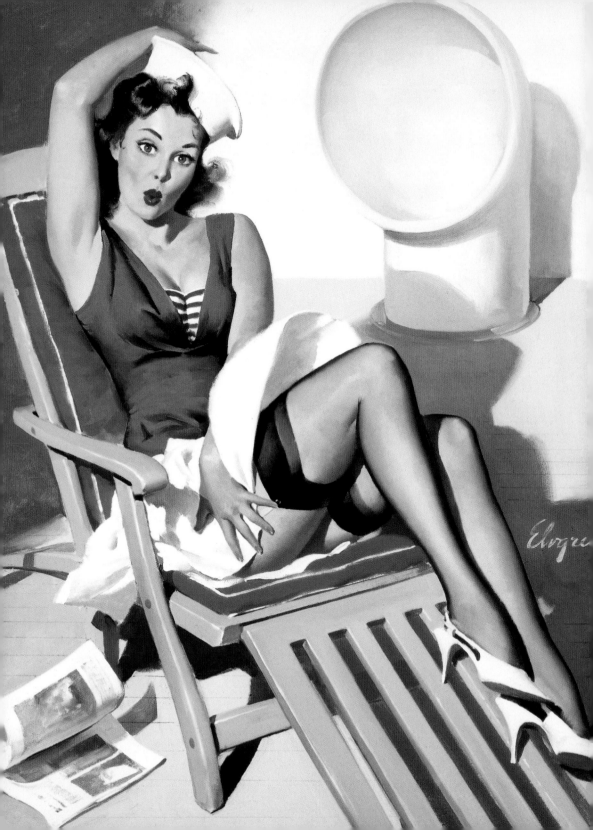

11.<small>■ WEEK</small>

03.2004

Monday Montag Lundi Lunes Lunedì Segunda-feira Maandag 月

8

Tuesday Dienstag Mardi Martes Martedì Terça-feira Dinsdag 火

9

Wednesday Mittwoch Mercredi Miércoles Mercoledì Quarta-feira Woensdag 水

10

Thursday Donnerstag Jeudi Jueves Giovedì Quinta-feira Donderdag 木

11

Friday Freitag Vendredi Viernes Venerdì Sexta-feira Vrijdag 金

12

Saturday Samstag Samedi Sábado Sabato Sábado Zaterdag 土
◑
13

Sunday Sonntag Dimanche Domingo Domenica Domingo Zondag 日

14

12. WEEK

03.2004

Monday	15	22	29	5	12
Tuesday	16	23	30	6	13
Wednesday	17	24	31	7	14
Thursday	18	25	1	8	15
Friday	19	26	2	9	16
Saturday	20	27	3	10	17
Sunday	21	28	4	11	18
WEEK	12	13	14	15	16

Monday Montag Lundi Lunes Lunedì Segunda-feira Maandag 月

15

Tuesday Dienstag Mardi Martes Martedì Terça-feira Dinsdag 火

16

Wednesday Mittwoch Mercredi Miércoles Mercoledì Quarta-feira Woensdag 水

(UK) Saint Patrick's Day
(Northern Ireland only)
(IRL) Saint Patrick's Day

17

Thursday Donnerstag Jeudi Jueves Giovedì Quinta-feira Donderdag 木

18

Friday Freitag Vendredi Viernes Venerdì Sexta-feira Vrijdag 金

19

Saturday Samstag Samedi Sábado Sabato Sábado Zaterdag 土

●

(J) Vernal Equinox Day

20

Sunday Sonntag Dimanche Domingo Domenica Domingo Zondag 日

21

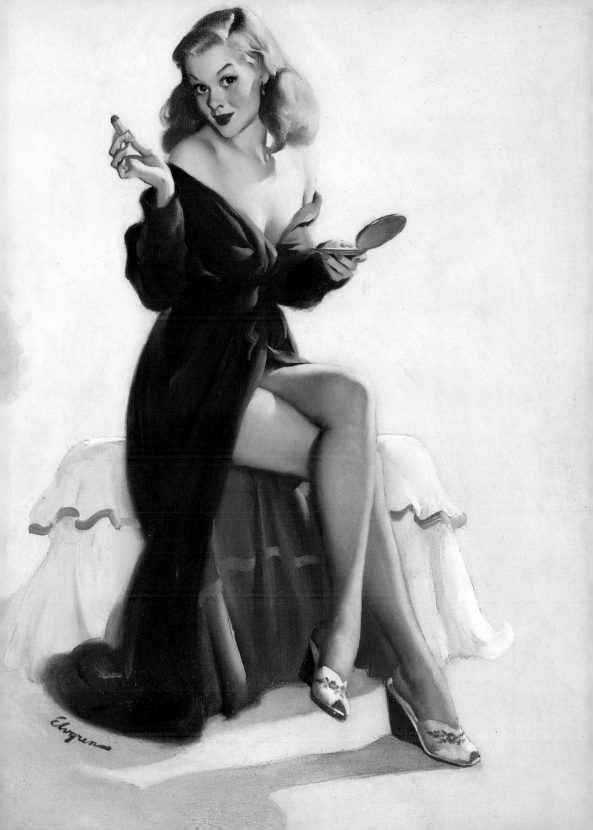

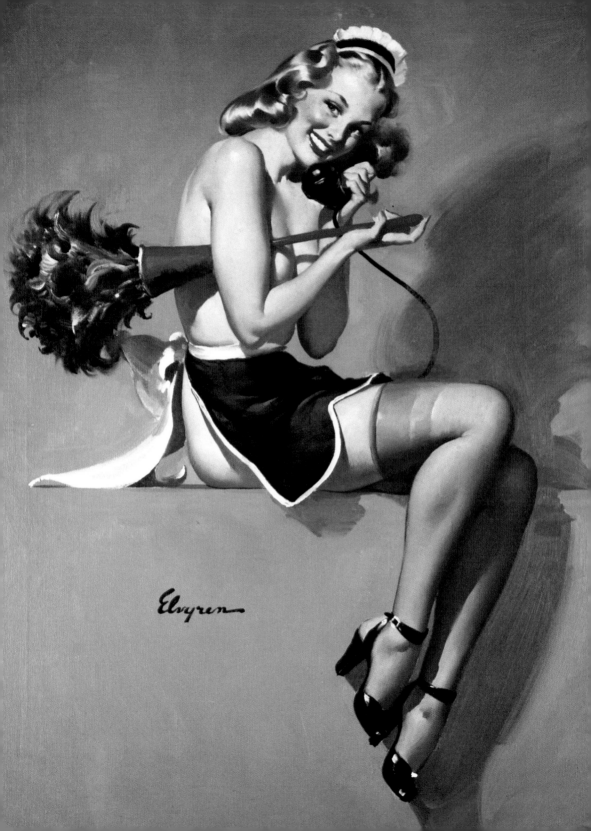

13.■ WEEK

03.2004

Monday	22	29	5	12	19
Tuesday	23	30	6	13	20
Wednesday	24	31	7	14	21
Thursday	25	1	8	15	22
Friday	26	2	9	16	23
Saturday	27	3	10	17	24
Sunday	28	4	11	18	25
WEEK	**13**	**14**	**15**	**16**	**17**

Monday Montag Lundi Lunes Lunedì Segunda-feira Maandag 月

22

Tuesday Dienstag Mardi Martes Martedì Terça-feira Dinsdag 火

23

Wednesday Mittwoch Mercredi Miércoles Mercoledì Quarta-feira Woensdag 水

24

Thursday Donnerstag Jeudi Jueves Giovedì Quinta-feira Donderdag 木

25

Friday Freitag Vendredi Viernes Venerdì Sexta-feira Vrijdag 金

26

Saturday Samstag Samedi Sábado Sabato Sábado Zaterdag 土

27

Sunday Sonntag Dimanche Domingo Domenica Domingo Zondag 日

28

14. WEEK

03|04.2004

Monday	29	5	12	19	26
Tuesday	30	6	13	20	27
Wednesday	31	7	14	21	28
Thursday	1	8	15	22	29
Friday	2	9	16	23	30
Saturday	3	10	17	24	1
Sunday	4	11	18	25	2
WEEK	**14**	**15**	**16**	**17**	**18**

Monday Montag Lundi Lunes Lunedì Segunda-feira Maandag 月

◖

29

Tuesday Dienstag Mardi Martes Martedì Terça-feira Dinsdag 火

30

Wednesday Mittwoch Mercredi Miércoles Mercoledì Quarta-feira Woensdag 水

31

Thursday Donnerstag Jeudi Jueves Giovedì Quinta-feira Donderdag 木

1

Friday Freitag Vendredi Viernes Venerdì Sexta-feira Vrijdag 金

2

Saturday Samstag Samedi Sábado Sabato Sábado Zaterdag 土

3

Sunday Sonntag Dimanche Domingo Domenica Domingo Zondag 日

4

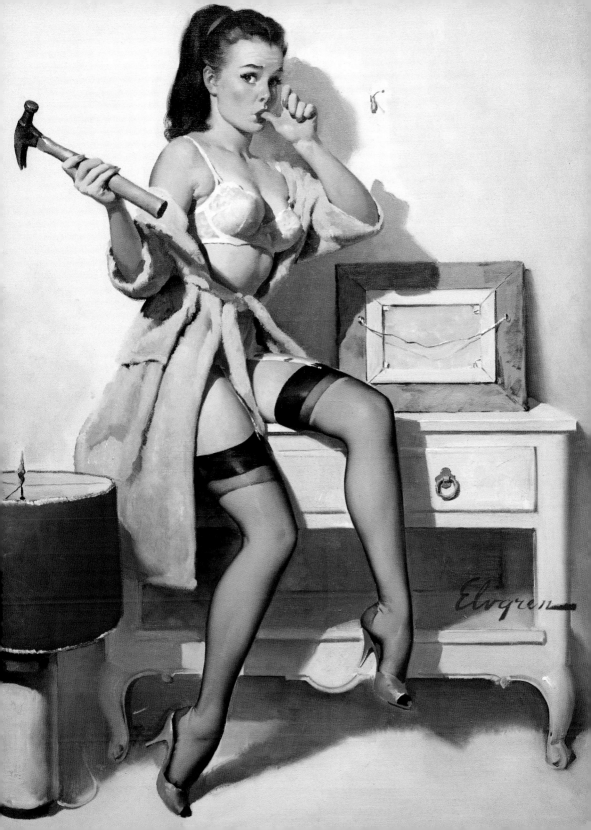

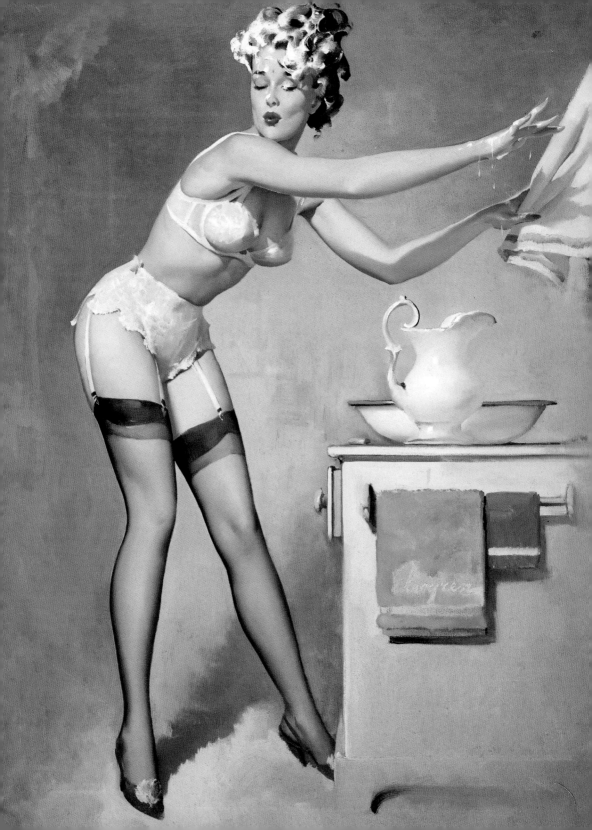

15. WEEK

04.2004

Monday Montag Lundi Lunes Lunedì Segunda-feira Maandag 月

○ (K) Arbor Day

5

Tuesday Dienstag Mardi Martes Martedì Terça-feira Dinsdag 火

(IL) Passover

6

Wednesday Mittwoch Mercredi Miércoles Mercoledì Quarta-feira Woensdag 水

7

Thursday Donnerstag Jeudi Jueves Giovedì Quinta-feira Donderdag 木

8

Friday Freitag Vendredi Viernes Venerdì Sexta-feira Vrijdag 金

(UK) (CDN) (D) (CH) (E) (P)
Good Friday | Vendredi Saint |
Karfreitag | Venerdì Santo |
Viernes Santo | Sexta-feira Santa

9

Saturday Samstag Samedi Sábado Sabato Sábado Zaterdag 土

10

Sunday Sonntag Dimanche Domingo Domenica Domingo Zondag 日

Easter Sunday | Pâques | Ostersonntag |
Pasqua | 1e Paasdag | Pascua |
Domingo de Páscoa

11

16. WEEK

04.2004

Monday	12	19	26	3	10
Tuesday	13	20	27	4	11
Wednesday	14	21	28	5	12
Thursday	15	22	29	6	13
Friday	16	23	30	7	14
Saturday	17	24	1	8	15
Sunday	18	25	2	9	16
WEEK	**16**	**17**	**18**	**19**	**20**

Monday Montag Lundi Lunes Lunedì Segunda-feira Maandag 月

◗

12

(UK) Easter Monday (except Scotland)

(IRL) (CDN) (F) (D) (A) (CH) (NL) (I)

Easter Monday | Lundi de Pâques |
Ostermontag | Lunedì di Pasqua |
2e Paasdag | Lunedì dell'Angelo

Tuesday Dienstag Mardi Martes Martedì Terça-feira Dinsdag 火

(IL) Passover

13

Wednesday Mittwoch Mercredi Miércoles Mercoledì Quarta-feira Woensdag 水

14

Thursday Donnerstag Jeudi Jueves Giovedì Quinta-feira Donderdag 木

15

Friday Freitag Vendredi Viernes Venerdì Sexta-feira Vrijdag 金

16

Saturday Samstag Samedi Sábado Sabato Sábado Zaterdag 土

17

Sunday Sonntag Dimanche Domingo Domenica Domingo Zondag 日

(IL) Yom Hashoah

18

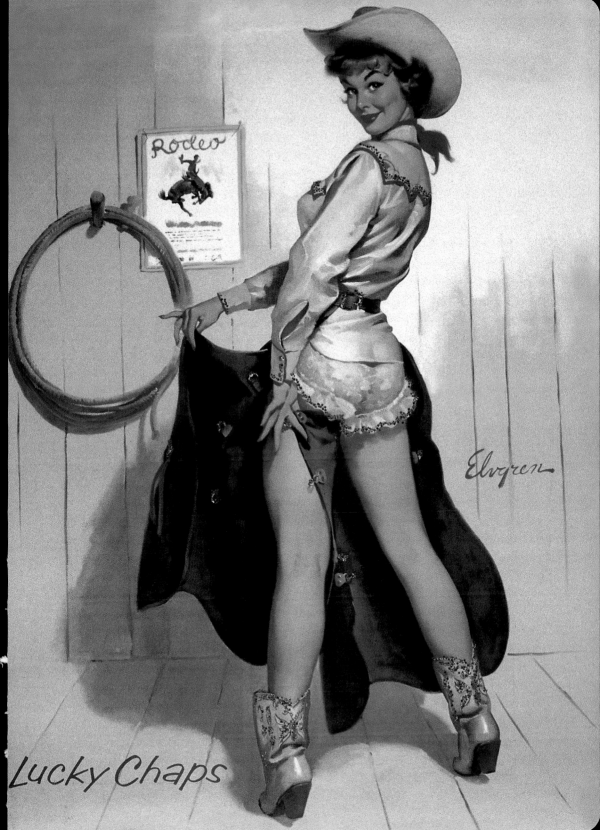

Rodeo

Elvgren

Lucky Chaps

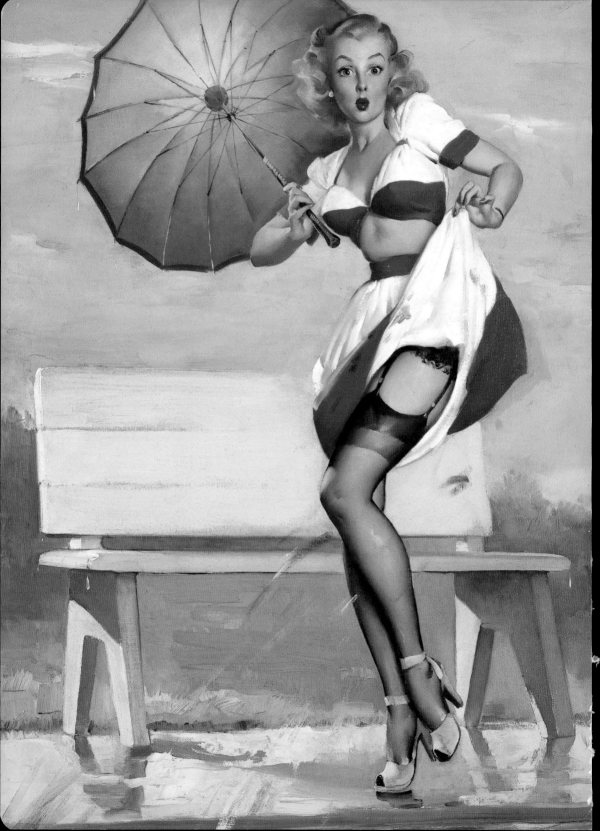

17. ■ WEEK

04.2004

Monday Montag Lundi Lunes Lunedì Segunda-feira Maandag 月

●

19

Tuesday Dienstag Mardi Martes Martedì Terça-feira Dinsdag 火

20

Wednesday Mittwoch Mercredi Miércoles Mercoledì Quarta-feira Woensdag 水

21

Thursday Donnerstag Jeudi Jueves Giovedì Quinta-feira Donderdag 木

22

Friday Freitag Vendredi Viernes Venerdì Sexta-feira Vrijdag 金

23

Saturday Samstag Samedi Sábado Sabato Sábado Zaterdag 土

24

Sunday Sonntag Dimanche Domingo Domenica Domingo Zondag 日

Ⓘ Liberazione
Ⓟ Dia da Liberdade

25

18. ■ WEEK

04|05.2004

Monday	26	3	10	17	24
Tuesday	27	4	11	18	25
Wednesday	28	5	12	19	26
Thursday	29	6	13	20	27
Friday	30	7	14	21	28
Saturday	1	8	15	22	29
Sunday	2	9	16	23	30
WEEK	**18**	**19**	**20**	**21**	**22**

Monday Montag Lundi Lunes Lunedì Segunda-feira Maandag 月

(IL) Yom Haatzmaut

26

Tuesday Dienstag Mardi Martes Martedì Terça-feira Dinsdag 火

◐

27

Wednesday Mittwoch Mercredi Miércoles Mercoledì Quarta-feira Woensdag 水

28

Thursday Donnerstag Jeudi Jueves Giovedì Quinta-feira Donderdag 木

(J) Greenery Day

29

Friday Freitag Vendredi Viernes Venerdì Sexta-feira Vrijdag 金

(NL) Koninginnedag

30

Saturday Samstag Samedi Sábado Sabato Sábado Zaterdag 土

(F) (D) (A) (E) (I) (P)
Fête du Travail | Maifeiertag |
Fiesta del Trabajo | Festa del
Lavoro | Dia do Trabalhador

1

Sunday Sonntag Dimanche Domingo Domenica Domingo Zondag 日

2

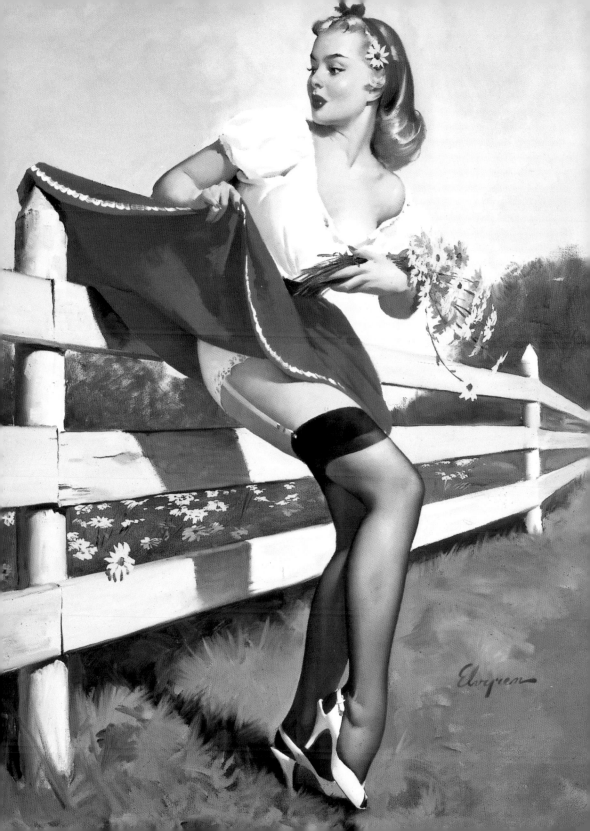

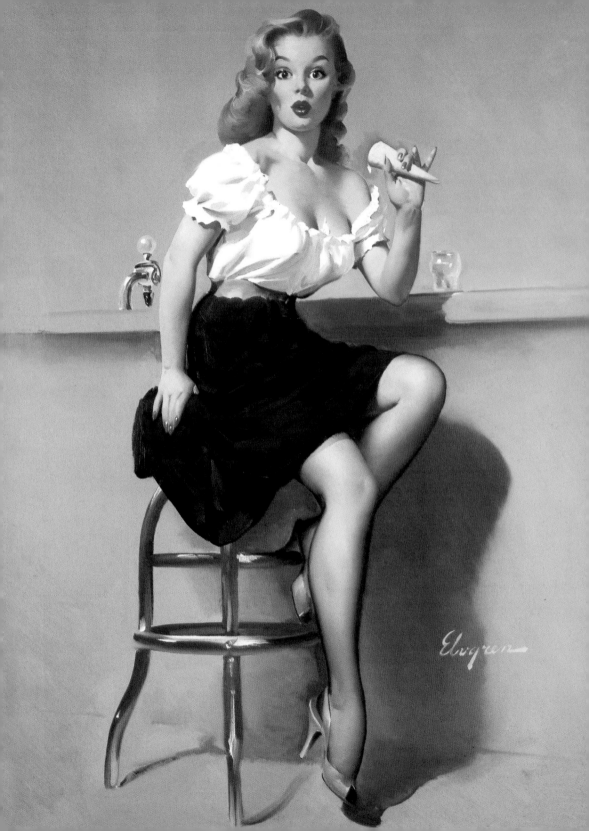

19. ∎ WEEK

05.2004

Monday Montag Lundi Lunes Lunedì Segunda-feira Maandag 月

(UK) May Bank Holiday
(IRL) First Monday in May
(J) Constitution Day

3

Tuesday Dienstag Mardi Martes Martedì Terça-feira Dinsdag 火

○

(J) Public Holiday

4

Wednesday Mittwoch Mercredi Miércoles Mercoledì Quarta-feira Woensdag 水

(J) (K)
Children's Day

5

Thursday Donnerstag Jeudi Jueves Giovedì Quinta-feira Donderdag 木

6

Friday Freitag Vendredi Viernes Venerdì Sexta-feira Vrijdag 金

7

Saturday Samstag Samedi Sábado Sabato Sábado Zaterdag 土

(F) Fête de la Libération

8

Sunday Sonntag Dimanche Domingo Domenica Domingo Zondag 日

9

20. WEEK

05.2004

Monday	10	17	24	31	7
Tuesday	11	18	25	1	8
Wednesday	12	19	26	2	9
Thursday	13	20	27	3	10
Friday	14	21	28	4	11
Saturday	15	22	29	5	12
Sunday	16	23	30	6	13
WEEK	20	21	22	23	24

Monday Montag Lundi Lunes Lunedì Segunda-feira Maandag 月

10

Tuesday Dienstag Mardi Martes Martedì Terça-feira Dinsdag 火

11

Wednesday Mittwoch Mercredi Miércoles Mercoledì Quarta-feira Woensdag 水

12

Thursday Donnerstag Jeudi Jueves Giovedì Quinta-feira Donderdag 木

13

Friday Freitag Vendredi Viernes Venerdì Sexta-feira Vrijdag 金

14

Saturday Samstag Samedi Sábado Sabato Sábado Zaterdag 土

15

Sunday Sonntag Dimanche Domingo Domenica Domingo Zondag 日

16

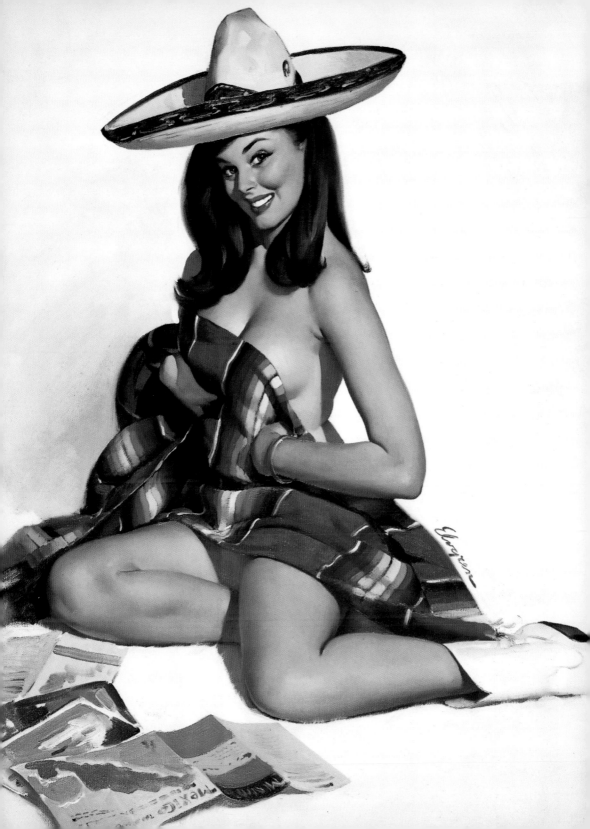

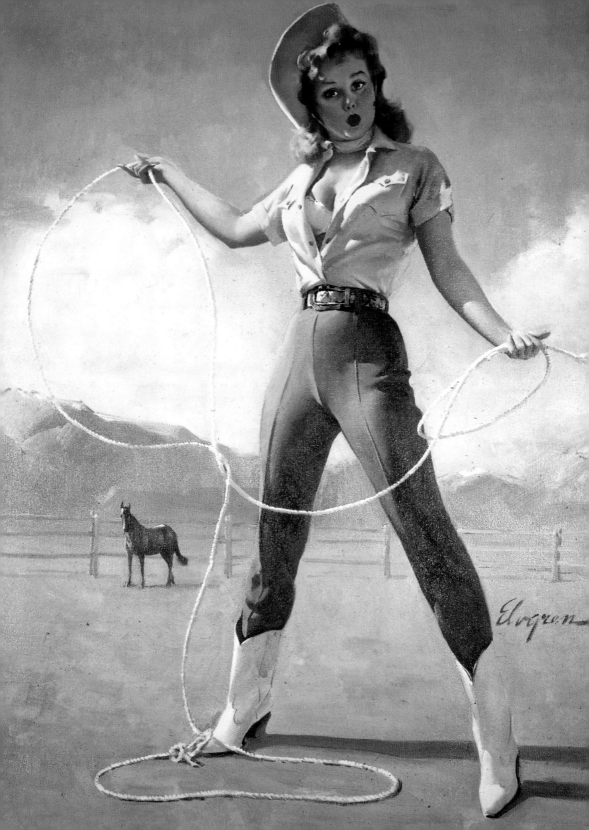

21. WEEK

05.2004

Monday	17	24	31	7	14
Tuesday	18	25	1	8	15
Wednesday	19	26	2	9	16
Thursday	20	27	3	10	17
Friday	21	28	4	11	18
Saturday	22	29	5	12	19
Sunday	23	30	6	13	20
WEEK	**21**	**22**	**23**	**24**	**25**

Monday Montag Lundi Lunes Lunedì Segunda-feira Maandag 月

17

Tuesday Dienstag Mardi Martes Martedì Terça-feira Dinsdag 火

18

Wednesday Mittwoch Mercredi Miércoles Mercoledì Quarta-feira Woensdag 水

●

19

Thursday Donnerstag Jeudi Jueves Giovedì Quinta-feira Donderdag 木

Ⓕ Ⓓ Ⓐ Ⓒⓗ Ⓝⓛ
Ascension | Christi Himmelfahrt |
Auffahrt | Ascensione |
Hemelvaartsdag

20

Friday Freitag Vendredi Viernes Venerdì Sexta-feira Vrijdag 金

21

Saturday Samstag Samedi Sábado Sabato Sábado Zaterdag 土

22

Sunday Sonntag Dimanche Domingo Domenica Domingo Zondag 日

23

22.■ WEEK

05.2004

Monday	24	31	7	14	21
Tuesday	25	1	8	15	22
Wednesday	26	2	9	16	23
Thursday	27	3	10	17	24
Friday	28	4	11	18	25
Saturday	29	5	12	19	26
Sunday	30	6	13	20	27
WEEK	22	23	24	25	26

Monday Montag Lundi Lunes Lunedì Segunda-feira Maandag 月

(CDN) Victoria Day | Fête de la Reine

24

Tuesday Dienstag Mardi Martes Martedì Terça-feira Dinsdag 火

25

Wednesday Mittwoch Mercredi Miércoles Mercoledì Quarta-feira Woensdag 水

(IL) Shavuot
(K) Buddha's Birthday

26

Thursday Donnerstag Jeudi Jueves Giovedì Quinta-feira Donderdag 木

☽

27

Friday Freitag Vendredi Viernes Venerdì Sexta-feira Vrijdag 金

28

Saturday Samstag Samedi Sábado Sabato Sábado Zaterdag 土

29

Sunday Sonntag Dimanche Domingo Domenica Domingo Zondag 日

(F) (D) (A) (CH) (NL)
Pentecôte | Pfingstsonntag |
Pentecoste | 1e Pinksterdag

30

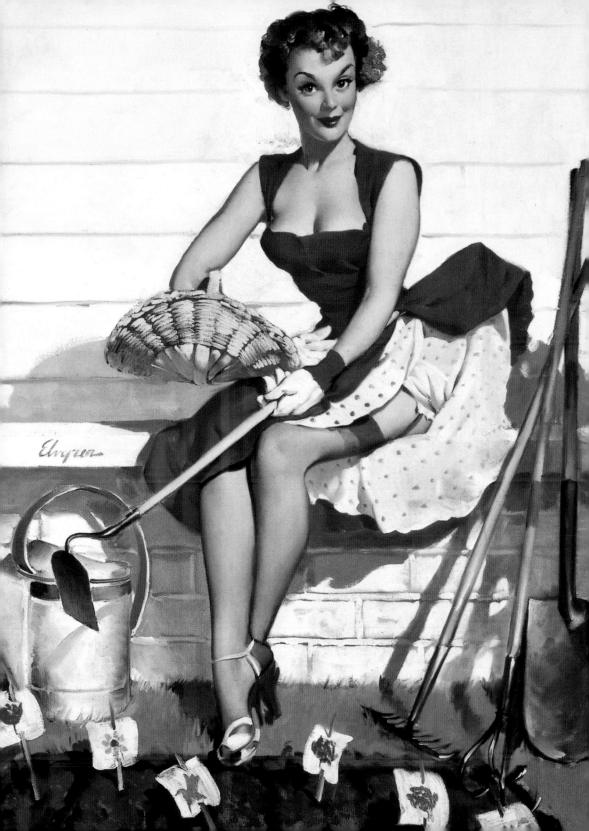

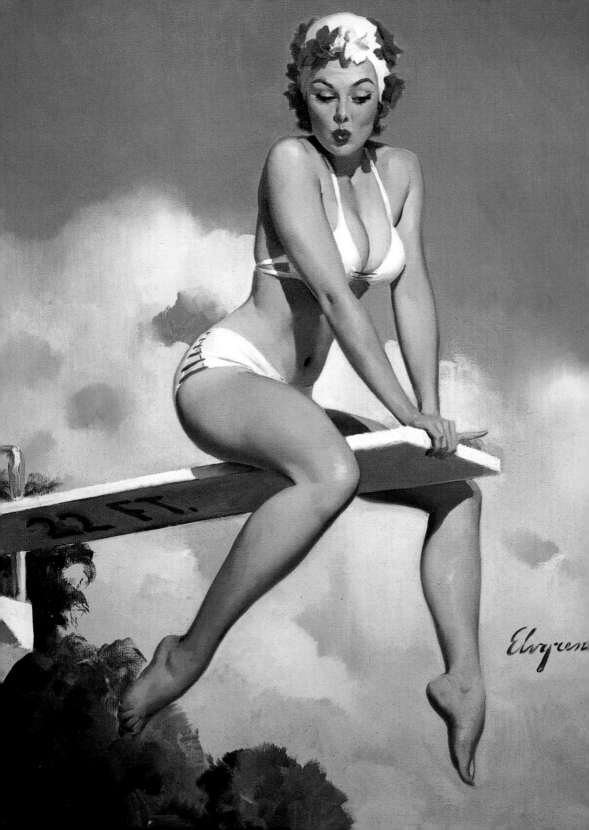

23. WEEK

05|06.2004

Monday	31	7	14	21	28
Tuesday	1	8	15	22	29
Wednesday	2	9	16	23	30
Thursday	3	10	17	24	1
Friday	4	11	18	25	2
Saturday	5	12	19	26	3
Sunday	6	13	20	27	4
WEEK	**23**	**24**	**25**	**26**	**27**

Monday Montag Lundi Lunes Lunedì Segunda-feira Maandag 月

(F) (D) (A) (CH) (NL)
Lundi de Pentecôte | Pfingstmontag |
Lunedì di Pentecoste | 2e Pinksterdag
(USA) Memorial Day
(UK) Spring Bank Holiday

31

Tuesday Dienstag Mardi Martes Martedì Terça-feira Dinsdag 火

1

Wednesday Mittwoch Mercredi Miércoles Mercoledì Quarta-feira Woensdag 水

(I) Festa della Repubblica

2

Thursday Donnerstag Jeudi Jueves Giovedì Quinta-feira Donderdag 木

○

3

Friday Freitag Vendredi Viernes Venerdì Sexta-feira Vrijdag 金

4

Saturday Samstag Samedi Sábado Sabato Sábado Zaterdag 土

5

Sunday Sonntag Dimanche Domingo Domenica Domingo Zondag 日

(K) Memorial Day

6

24. WEEK

06.2004

Monday	7	14	21	28	5
Tuesday	8	15	22	29	6
Wednesday	9	16	23	30	7
Thursday	10	17	24	1	8
Friday	11	18	25	2	9
Saturday	12	19	26	3	10
Sunday	13	20	27	4	11
WEEK	**24**	**25**	**26**	**27**	**28**

Monday Montag Lundi Lunes Lunedì Segunda-feira Maandag 月

(IRL) First Monday in June

7

Tuesday Dienstag Mardi Martes Martedì Terça-feira Dinsdag 火

8

Wednesday Mittwoch Mercredi Miércoles Mercoledì Quarta-feira Woensdag 水

◗

9

Thursday Donnerstag Jeudi Jueves Giovedì Quinta-feira Donderdag 木

(D) Fronleichnam (teilweise)
(A) Fronleichnam
(P) Corpo de Deus / Dia Nacional

10

Friday Freitag Vendredi Viernes Venerdì Sexta-feira Vrijdag 金

11

Saturday Samstag Samedi Sábado Sabato Sábado Zaterdag 土

12

Sunday Sonntag Dimanche Domingo Domenica Domingo Zondag 日

13

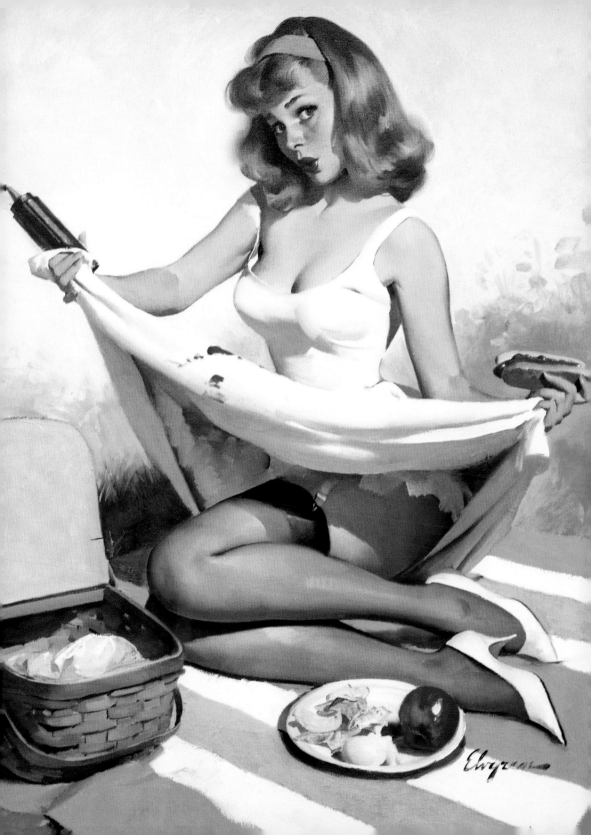

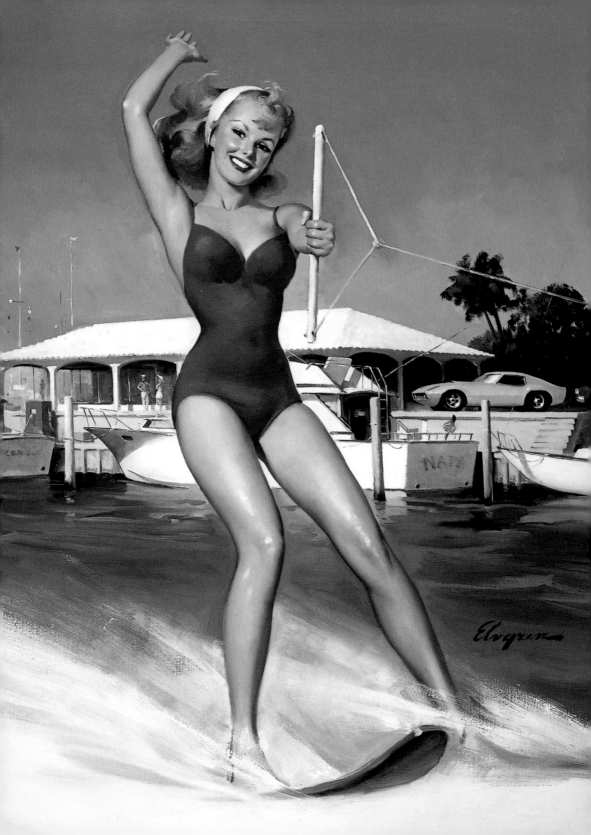

25. ■ WEEK

06.2004

Monday	14	21	28	5	12
Tuesday	15	22	29	6	13
Wednesday	16	23	30	7	14
Thursday	17	24	1	8	15
Friday	18	25	2	9	16
Saturday	19	26	3	10	17
Sunday	20	27	4	11	18
WEEK	**25**	**26**	**27**	**28**	**29**

Monday Montag Lundi Lunes Lunedì Segunda-feira Maandag 月

14

Tuesday Dienstag Mardi Martes Martedì Terça-feira Dinsdag 火

15

Wednesday Mittwoch Mercredi Miércoles Mercoledì Quarta-feira Woensdag 水

16

Thursday Donnerstag Jeudi Jueves Giovedì Quinta-feira Donderdag 木

17

Friday Freitag Vendredi Viernes Venerdì Sexta-feira Vrijdag 金

18

Saturday Samstag Samedi Sábado Sabato Sábado Zaterdag 土

19

Sunday Sonntag Dimanche Domingo Domenica Domingo Zondag 日

20

26. ■ WEEK

06.2004

Monday	21	28	5	12	19
Tuesday	22	29	6	13	20
Wednesday	23	30	7	14	21
Thursday	24	1	8	15	22
Friday	25	2	9	16	23
Saturday	26	3	10	17	24
Sunday	27	4	11	18	25
WEEK	**26**	**27**	**28**	**29**	**30**

Monday Montag Lundi Lunes Lunedì Segunda-feira Maandag 月

21

Tuesday Dienstag Mardi Martes Martedì Terça-feira Dinsdag 火

22

Wednesday Mittwoch Mercredi Miércoles Mercoledì Quarta-feira Woensdag 水

23

Thursday Donnerstag Jeudi Jueves Giovedì Quinta-feira Donderdag 木

24

Friday Freitag Vendredi Viernes Venerdì Sexta-feira Vrijdag 金

◗

25

Saturday Samstag Samedi Sábado Sabato Sábado Zaterdag 土

26

Sunday Sonntag Dimanche Domingo Domenica Domingo Zondag 日

27

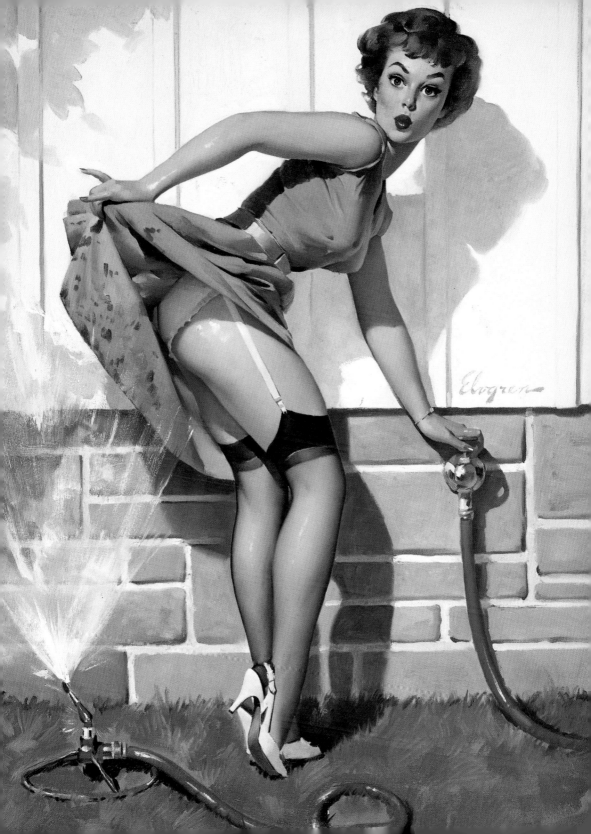

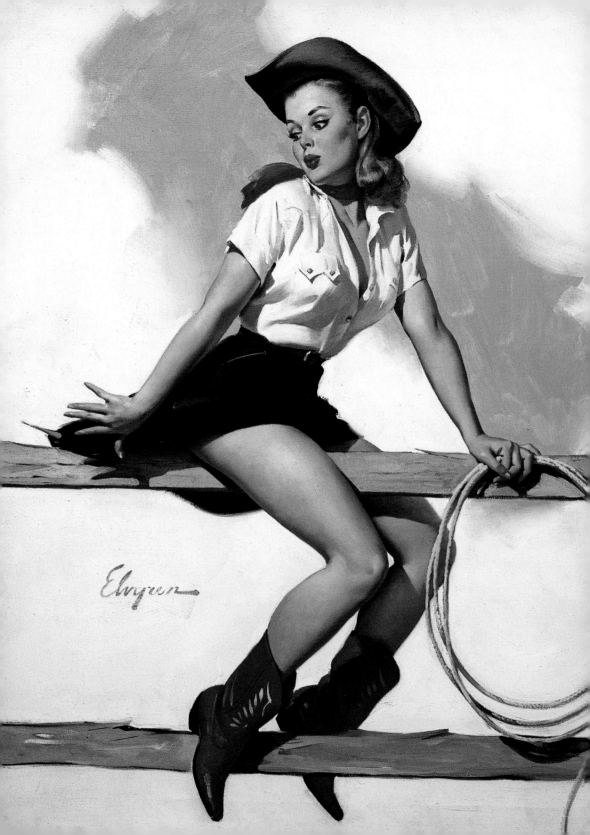

27. WEEK

06 | 07.2004

Monday Montag Lundi Lunes Lunedì Segunda-feira Maandag 月

28

Tuesday Dienstag Mardi Martes Martedì Terça-feira Dinsdag 火

29

Wednesday Mittwoch Mercredi Miércoles Mercoledì Quarta-feira Woensdag 水

30

Thursday Donnerstag Jeudi Jueves Giovedì Quinta-feira Donderdag 木

CDN Canada Day | Fête du Canada

1

Friday Freitag Vendredi Viernes Venerdì Sexta-feira Vrijdag 金

○

2

Saturday Samstag Samedi Sábado Sabato Sábado Zaterdag 土

3

Sunday Sonntag Dimanche Domingo Domenica Domingo Zondag 日

USA Independence Day

4

28. WEEK

07.2004

Monday	5	12	19	26	2
Tuesday	6	13	20	27	3
Wednesday	7	14	21	28	4
Thursday	8	15	22	29	5
Friday	9	16	23	30	6
Saturday	10	17	24	31	7
Sunday	11	18	25	1	8
WEEK	**28**	**29**	**30**	**31**	**32**

Monday Montag Lundi Lunes Lunedì Segunda-feira Maandag 月

5

Tuesday Dienstag Mardi Martes Martedì Terça-feira Dinsdag 火

6

Wednesday Mittwoch Mercredi Miércoles Mercoledì Quarta-feira Woensdag 水

7

Thursday Donnerstag Jeudi Jueves Giovedì Quinta-feira Donderdag 木

8

Friday Freitag Vendredi Viernes Venerdì Sexta-feira Vrijdag 金

9

Saturday Samstag Samedi Sábado Sabato Sábado Zaterdag 土

10

Sunday Sonntag Dimanche Domingo Domenica Domingo Zondag 日

11

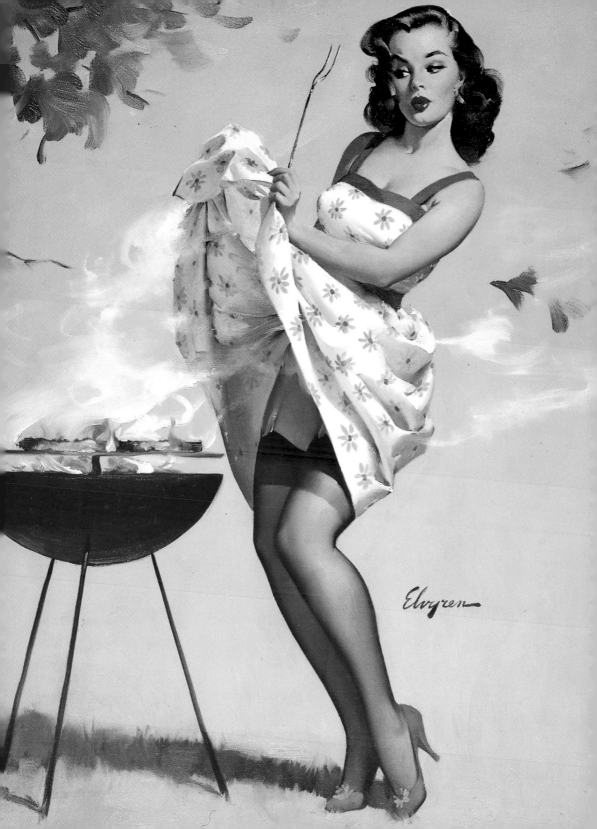

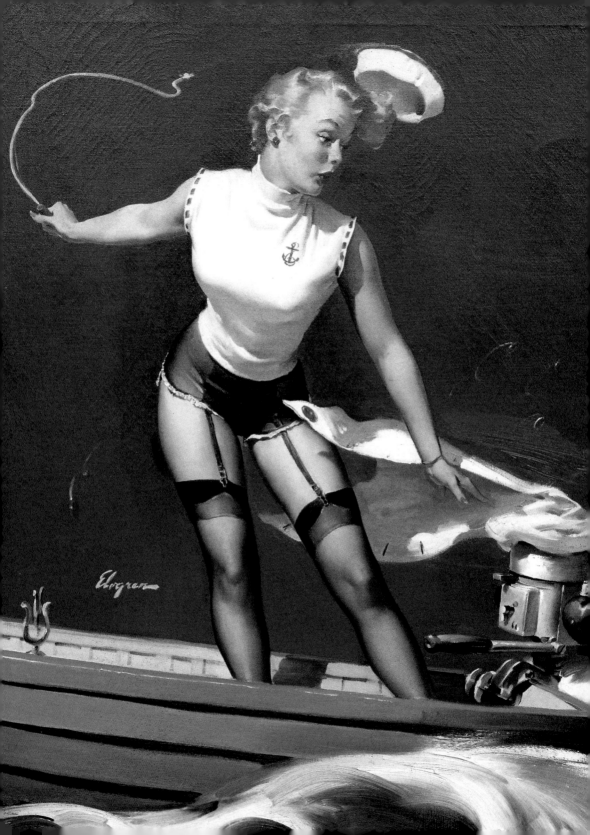

29. ■ WEEK

07.2004

Monday	12	19	26	2	9
Tuesday	13	20	27	3	10
Wednesday	14	21	28	4	11
Thursday	15	22	29	5	12
Friday	16	23	30	6	13
Saturday	17	24	31	7	14
Sunday	18	25	1	8	15
WEEK	**29**	**30**	**31**	**32**	**33**

Monday Montag Lundi Lunes Lunedì Segunda-feira Maandag 月

(UK) Battle of the Boyne Day

(Northern Ireland only)

12

Tuesday Dienstag Mardi Martes Martedì Terça-feira Dinsdag 火

13

Wednesday Mittwoch Mercredi Miércoles Mercoledì Quarta-feira Woensdag 水

(F) Fête Nationale

14

Thursday Donnerstag Jeudi Jueves Giovedì Quinta-feira Donderdag 木

15

Friday Freitag Vendredi Viernes Venerdì Sexta-feira Vrijdag 金

16

Saturday Samstag Samedi Sábado Sabato Sábado Zaterdag 土

●

(K) Constitution Day

17

Sunday Sonntag Dimanche Domingo Domenica Domingo Zondag 日

18

30. WEEK

07.2004

Monday Montag Lundi Lunes Lunedì Segunda-feira Maandag 月

(J) Marine Day

19

Tuesday Dienstag Mardi Martes Martedì Terça-feira Dinsdag 火

20

Wednesday Mittwoch Mercredi Miércoles Mercoledì Quarta-feira Woensdag 水

21

Thursday Donnerstag Jeudi Jueves Giovedì Quinta-feira Donderdag 木

22

Friday Freitag Vendredi Viernes Venerdì Sexta-feira Vrijdag 金

23

Saturday Samstag Samedi Sábado Sabato Sábado Zaterdag 土

24

Sunday Sonntag Dimanche Domingo Domenica Domingo Zondag 日

◑

25

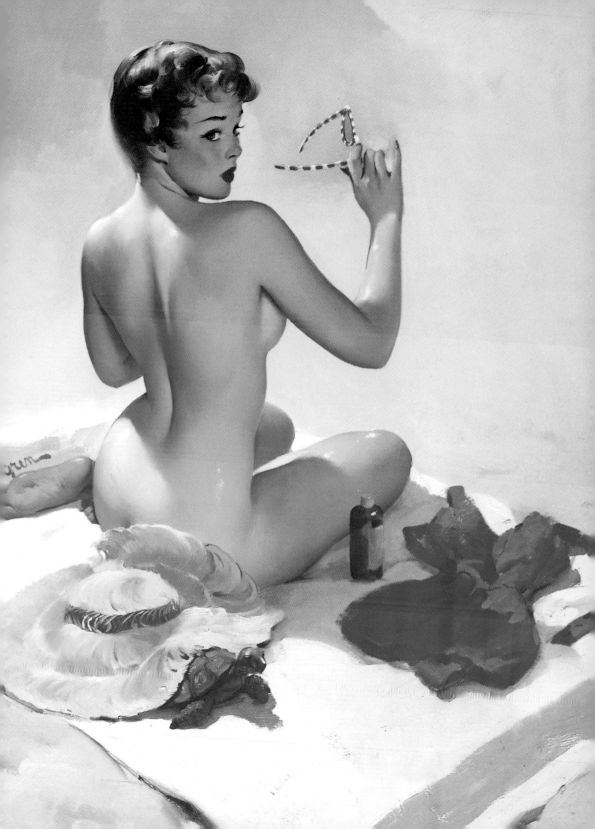

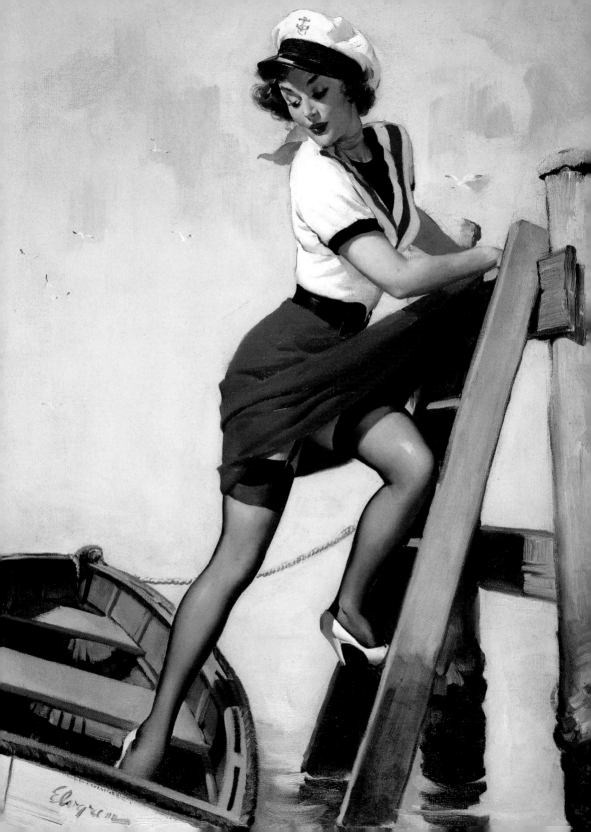

31. WEEK

07|08.2004

Monday	26	2	9	16	23
Tuesday	27	3	10	17	24
Wednesday	28	4	11	18	25
Thursday	29	5	12	19	26
Friday	30	6	13	20	27
Saturday	31	7	14	21	28
Sunday	1	8	15	22	29
WEEK	**31**	**32**	**33**	**34**	**35**

Monday Montag Lundi Lunes Lunedì Segunda-feira Maandag 月

26

Tuesday Dienstag Mardi Martes Martedì Terça-feira Dinsdag 火

(IL) Tisha B'Av

27

Wednesday Mittwoch Mercredi Miércoles Mercoledì Quarta-feira Woensdag 水

28

Thursday Donnerstag Jeudi Jueves Giovedì Quinta-feira Donderdag 木

29

Friday Freitag Vendredi Viernes Venerdì Sexta-feira Vrijdag 金

30

Saturday Samstag Samedi Sábado Sabato Sábado Zaterdag 土

○

31

Sunday Sonntag Dimanche Domingo Domenica Domingo Zondag 日

(CH) Bundesfeiertag | Fête nationale |
Festa nazionale

1

32. WEEK

08.2004

Monday	2	9	16	23	30
Tuesday	3	10	17	24	31
Wednesday	4	11	18	25	1
Thursday	5	12	19	26	2
Friday	6	13	20	27	3
Saturday	7	14	21	28	4
Sunday	8	15	22	29	5
WEEK	**32**	**33**	**34**	**35**	**36**

Monday Montag Lundi Lunes Lunedì Segunda-feira Maandag 月

2

(UK) Summer Bank Holiday
(Scotland only)
(IRL) First Monday in August

Tuesday Dienstag Mardi Martes Martedì Terça-feira Dinsdag 火

3

Wednesday Mittwoch Mercredi Miércoles Mercoledì Quarta-feira Woensdag 水

4

Thursday Donnerstag Jeudi Jueves Giovedì Quinta-feira Donderdag 木

5

Friday Freitag Vendredi Viernes Venerdì Sexta-feira Vrijdag 金

6

Saturday Samstag Samedi Sábado Sabato Sábado Zaterdag 土

7

Sunday Sonntag Dimanche Domingo Domenica Domingo Zondag 日

8

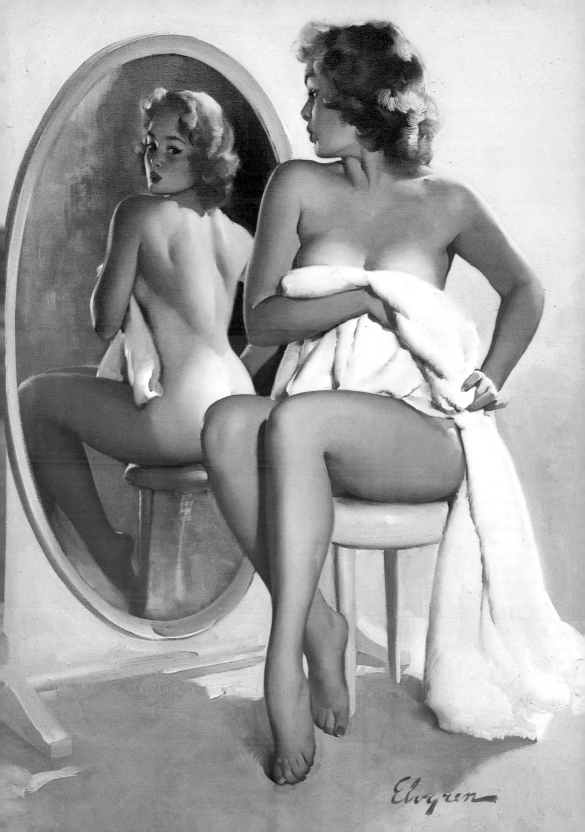

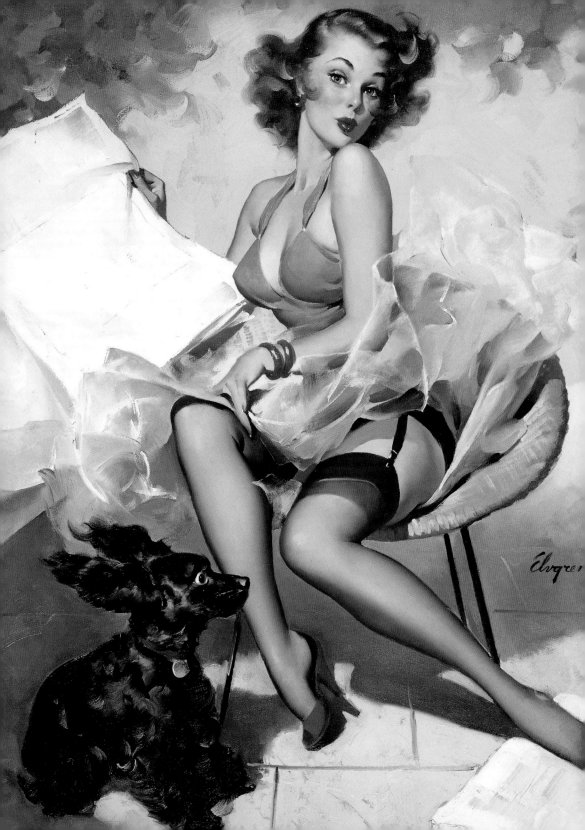

33. WEEK

08.2004

Monday Montag Lundi Lunes Lunedì Segunda-feira Maandag 月

9

Tuesday Dienstag Mardi Martes Martedì Terça-feira Dinsdag 火

10

Wednesday Mittwoch Mercredi Miércoles Mercoledì Quarta-feira Woensdag 水

11

Thursday Donnerstag Jeudi Jueves Giovedì Quinta-feira Donderdag 木

12

Friday Freitag Vendredi Viernes Venerdì Sexta-feira Vrijdag 金

13

Saturday Samstag Samedi Sábado Sabato Sábado Zaterdag 土

14

Sunday Sonntag Dimanche Domingo Domenica Domingo Zondag 日

15

(D) Mariä Himmelfahrt (teilweise)

(F) (A) (E) (I) (P)

Assomption | Mariä Himmelfahrt |
Asunción de la Virgen | Assunzione |
Assunção de Nossa Senhora

(K) Independence Day

34. WEEK

08.2004

Monday	16	23	30	6	13
Tuesday	17	24	31	7	14
Wednesday	18	25	1	8	15
Thursday	19	26	2	9	16
Friday	20	27	3	10	17
Saturday	21	28	4	11	18
Sunday	22	29	5	12	19
WEEK	**34**	**35**	**36**	**37**	**38**

Monday Montag Lundi Lunes Lunedì Segunda-feira Maandag 月

16

Tuesday Dienstag Mardi Martes Martedì Terça-feira Dinsdag 火

17

Wednesday Mittwoch Mercredi Miércoles Mercoledì Quarta-feira Woensdag 水

18

Thursday Donnerstag Jeudi Jueves Giovedì Quinta-feira Donderdag 木

19

Friday Freitag Vendredi Viernes Venerdì Sexta-feira Vrijdag 金

20

Saturday Samstag Samedi Sábado Sabato Sábado Zaterdag 土

21

Sunday Sonntag Dimanche Domingo Domenica Domingo Zondag 日

22

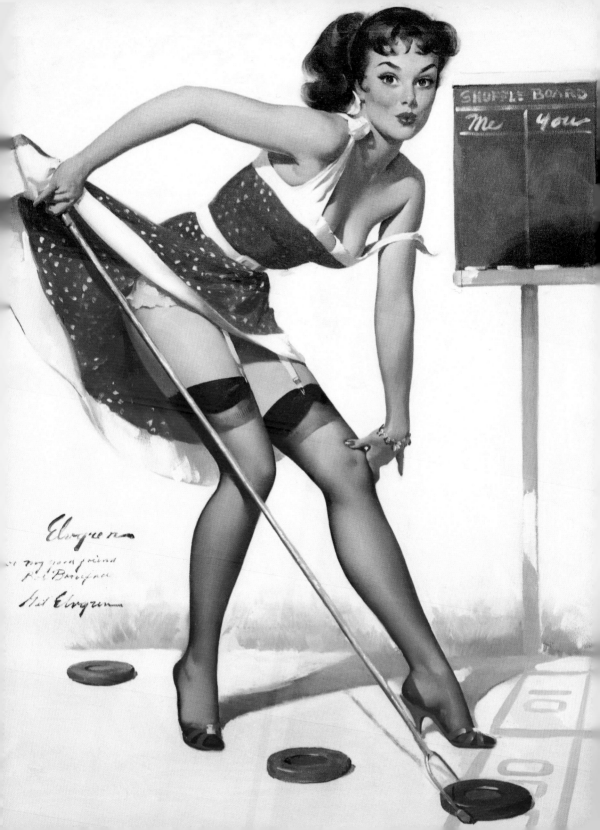

SHUFFLE BOARD
Me | You

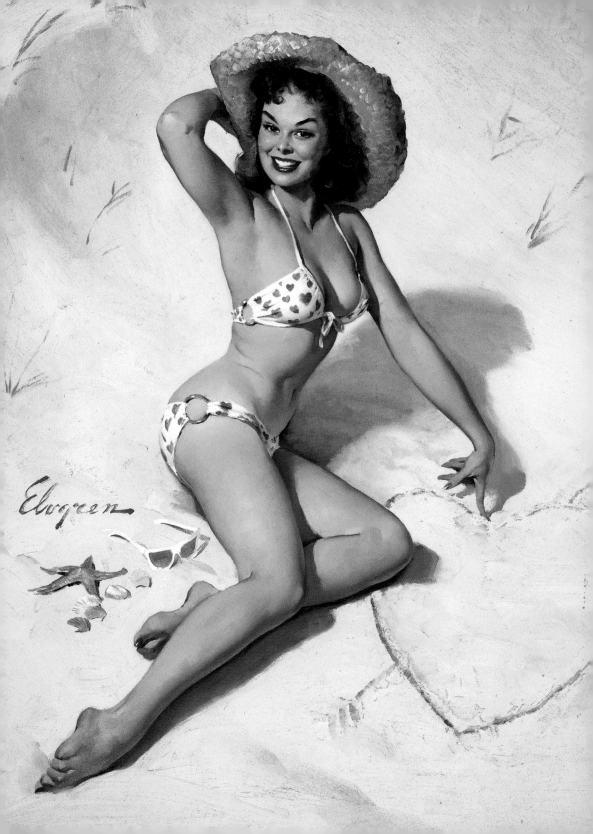

35. ■ WEEK

08.2004

Monday	23	30	6	13	20
Tuesday	24	31	7	14	21
Wednesday	25	1	8	15	22
Thursday	26	2	9	16	23
Friday	27	3	10	17	24
Saturday	28	4	11	18	25
Sunday	29	5	12	19	26
WEEK	**35**	**36**	**37**	**38**	**39**

Monday Montag Lundi Lunes Lunedì Segunda-feira Maandag 月

◑

23

Tuesday Dienstag Mardi Martes Martedì Terça-feira Dinsdag 火

24

Wednesday Mittwoch Mercredi Miércoles Mercoledì Quarta-feira Woensdag 水

25

Thursday Donnerstag Jeudi Jueves Giovedì Quinta-feira Donderdag 木

26

Friday Freitag Vendredi Viernes Venerdì Sexta-feira Vrijdag 金

27

Saturday Samstag Samedi Sábado Sabato Sábado Zaterdag 土

28

Sunday Sonntag Dimanche Domingo Domenica Domingo Zondag 日

29

36. ■ WEEK

08|09.2004

Monday Montag Lundi Lunes Lunedì Segunda-feira Maandag 月

○
(UK) Summer Bank Holiday
(except Scotland)

30

Tuesday Dienstag Mardi Martes Martedì Terça-feira Dinsdag 火

31

Wednesday Mittwoch Mercredi Miércoles Mercoledì Quarta-feira Woensdag 水

1

Thursday Donnerstag Jeudi Jueves Giovedì Quinta-feira Donderdag 木

2

Friday Freitag Vendredi Viernes Venerdì Sexta-feira Vrijdag 金

3

Saturday Samstag Samedi Sábado Sabato Sábado Zaterdag 土

4

Sunday Sonntag Dimanche Domingo Domenica Domingo Zondag 日

5

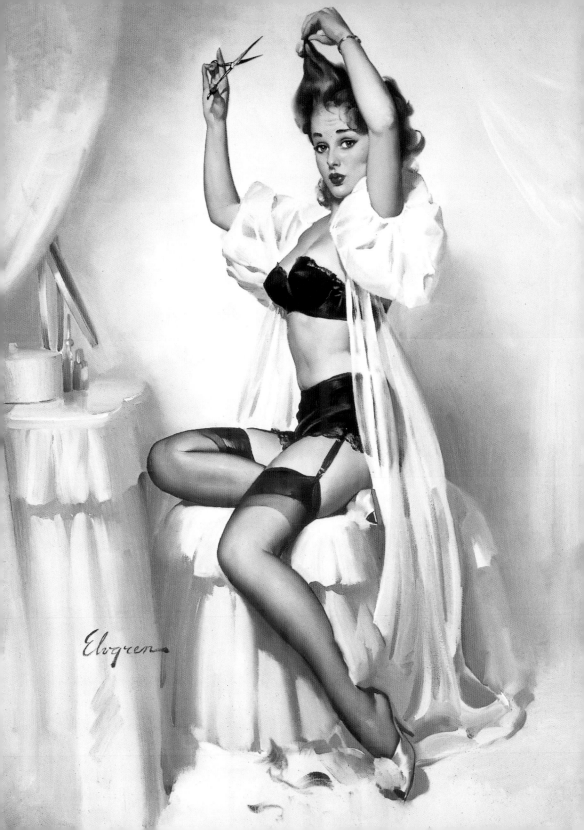

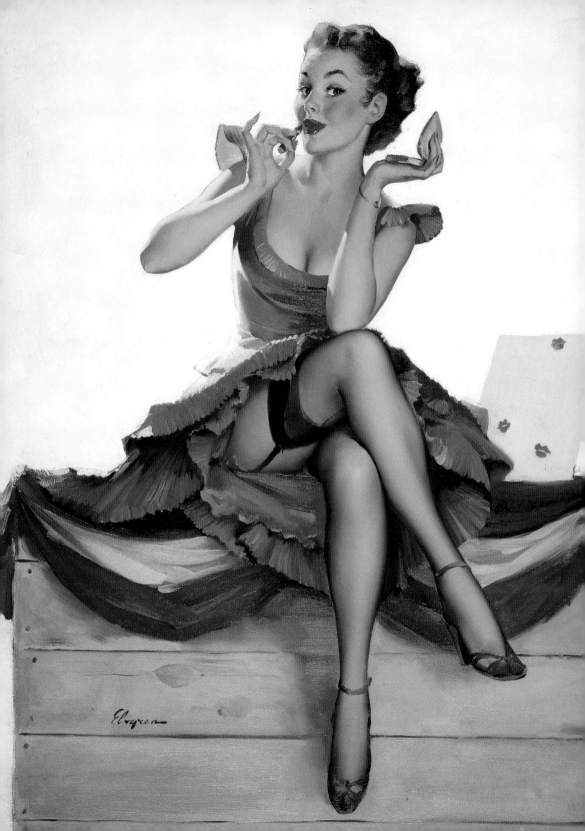

37. WEEK

09.2004

Monday	6	13	20	27	4
Tuesday	7	14	21	28	5
Wednesday	8	15	22	29	6
Thursday	9	16	23	30	7
Friday	10	17	24	1	8
Saturday	11	18	25	2	9
Sunday	12	19	26	3	10
WEEK	**37**	**38**	**39**	**40**	**41**

Monday Montag Lundi Lunes Lunedì Segunda-feira Maandag 月

◗ (USA) Labor Day

 (CDN) Labour Day | Fête du Travail

6

Tuesday Dienstag Mardi Martes Martedì Terça-feira Dinsdag 火

7

Wednesday Mittwoch Mercredi Miércoles Mercoledì Quarta-feira Woensdag 水

8

Thursday Donnerstag Jeudi Jueves Giovedì Quinta-feira Donderdag 木

9

Friday Freitag Vendredi Viernes Venerdì Sexta-feira Vrijdag 金

10

Saturday Samstag Samedi Sábado Sabato Sábado Zaterdag 土

11

Sunday Sonntag Dimanche Domingo Domenica Domingo Zondag 日

12

38. WEEK

09.2004

Monday	13	20	27	4	11
Tuesday	14	21	28	5	12
Wednesday	15	22	29	6	13
Thursday	16	23	30	7	14
Friday	17	24	1	8	15
Saturday	18	25	2	9	16
Sunday	19	26	3	10	17
WEEK	38	39	40	41	42

Monday Montag Lundi Lunes Lunedì Segunda-feira Maandag 月

13

Tuesday Dienstag Mardi Martes Martedì Terça-feira Dinsdag 火

●

14

Wednesday Mittwoch Mercredi Miércoles Mercoledì Quarta-feira Woensdag 水

15

Thursday Donnerstag Jeudi Jueves Giovedì Quinta-feira Donderdag 木

(IL) Rosh Hashanah

16

Friday Freitag Vendredi Viernes Venerdì Sexta-feira Vrijdag 金

17

Saturday Samstag Samedi Sábado Sabato Sábado Zaterdag 土

18

Sunday Sonntag Dimanche Domingo Domenica Domingo Zondag 日

19

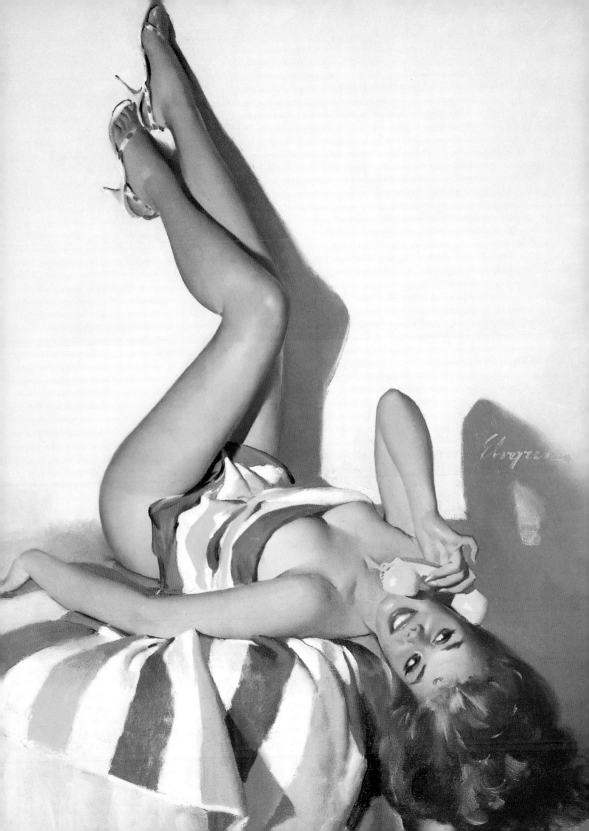

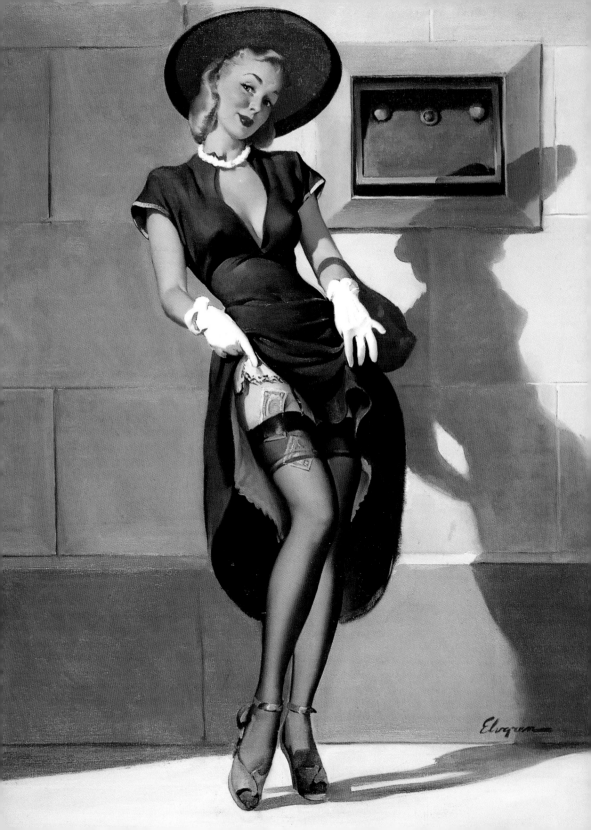

39. ■ WEEK

09.2004

Monday Montag Lundi Lunes Lunedì Segunda-feira Maandag 月

ⓙ Respect-for-the-Aged Day

20

Tuesday Dienstag Mardi Martes Martedì Terça-feira Dinsdag 火

◗

21

Wednesday Mittwoch Mercredi Miércoles Mercoledì Quarta-feira Woensdag 水

22

Thursday Donnerstag Jeudi Jueves Giovedì Quinta-feira Donderdag 木

ⓙ Autumn Equinox Day

23

Friday Freitag Vendredi Viernes Venerdì Sexta-feira Vrijdag 金

24

Saturday Samstag Samedi Sábado Sabato Sábado Zaterdag 土

ⓘⓛ Yom Kippur

25

Sunday Sonntag Dimanche Domingo Domenica Domingo Zondag 日

26

40. WEEK

09|10.2004

Monday	27	4	11	18	25
Tuesday	28	5	12	19	26
Wednesday	29	6	13	20	27
Thursday	30	7	14	21	28
Friday	1	8	15	22	29
Saturday	2	9	16	23	30
Sunday	3	10	17	24	31
WEEK	**40**	**41**	**42**	**43**	**44**

Monday Montag Lundi Lunes Lunedì Segunda-feira Maandag 月

27

Tuesday Dienstag Mardi Martes Martedì Terça-feira Dinsdag 火

○ (K) Thanksgiving Day

28

Wednesday Mittwoch Mercredi Miércoles Mercoledì Quarta-feira Woensdag 水

29

Thursday Donnerstag Jeudi Jueves Giovedì Quinta-feira Donderdag 木

(IL) Succoth

30

Friday Freitag Vendredi Viernes Venerdì Sexta-feira Vrijdag 金

1

Saturday Samstag Samedi Sábado Sabato Sábado Zaterdag 土

2

Sunday Sonntag Dimanche Domingo Domenica Domingo Zondag 日

(D) Tag der Deutschen Einheit
(K) National Foundation Day

3

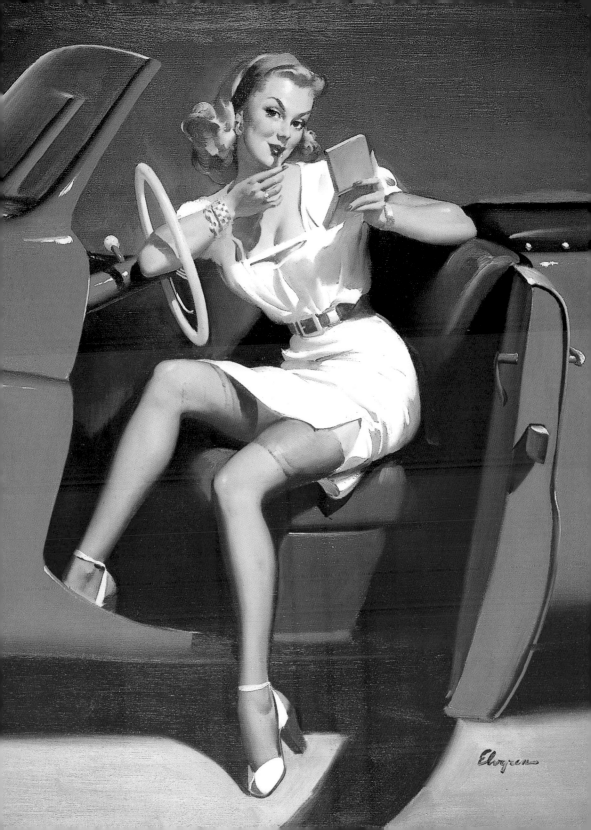

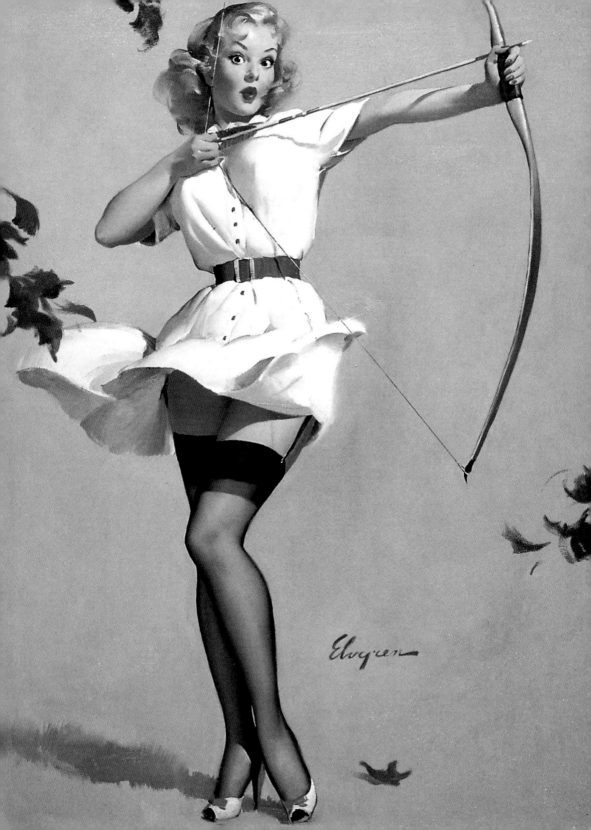

Elvgren

41. ■ WEEK

10.2004

Monday	4	11	18	25	1
Tuesday	5	12	19	26	2
Wednesday	6	13	20	27	3
Thursday	7	14	21	28	4
Friday	8	15	22	29	5
Saturday	9	16	23	30	6
Sunday	10	17	24	31	7
WEEK	**41**	**42**	**43**	**44**	**45**

Monday Montag Lundi Lunes Lunedì Segunda-feira Maandag 月

4

Tuesday Dienstag Mardi Martes Martedì Terça-feira Dinsdag 火

Ⓟ Implantação da República

5

Wednesday Mittwoch Mercredi Miércoles Mercoledì Quarta-feira Woensdag 水

◐

6

Thursday Donnerstag Jeudi Jueves Giovedì Quinta-feira Donderdag 木

ⒾⓁ Sh'mini Atzereth

7

Friday Freitag Vendredi Viernes Venerdì Sexta-feira Vrijdag 金

ⒾⓁ Simchat Torah

8

Saturday Samstag Samedi Sábado Sabato Sábado Zaterdag 土

Ⓚ Hangeul Proclamation Day

9

Sunday Sonntag Dimanche Domingo Domenica Domingo Zondag 日

10

42. WEEK

10.2004

Monday	11	18	25	1	8
Tuesday	12	19	26	2	9
Wednesday	13	20	27	3	10
Thursday	14	21	28	4	11
Friday	15	22	29	5	12
Saturday	16	23	30	6	13
Sunday	17	24	31	7	14
WEEK	**42**	**43**	**44**	**45**	**46**

Monday Montag Lundi Lunes Lunedì Segunda-feira Maandag 月

(USA) Columbus Day
(CDN) Thanksgiving Day | Action de Grâces
(J) Health-Sports Day

11

Tuesday Dienstag Mardi Martes Martedì Terça-feira Dinsdag 火

(E) Fiesta Nacional

12

Wednesday Mittwoch Mercredi Miércoles Mercoledì Quarta-feira Woensdag 水

13

Thursday Donnerstag Jeudi Jueves Giovedì Quinta-feira Donderdag 木

●

14

Friday Freitag Vendredi Viernes Venerdì Sexta-feira Vrijdag 金

15

Saturday Samstag Samedi Sábado Sabato Sábado Zaterdag 土

16

Sunday Sonntag Dimanche Domingo Domenica Domingo Zondag 日

17

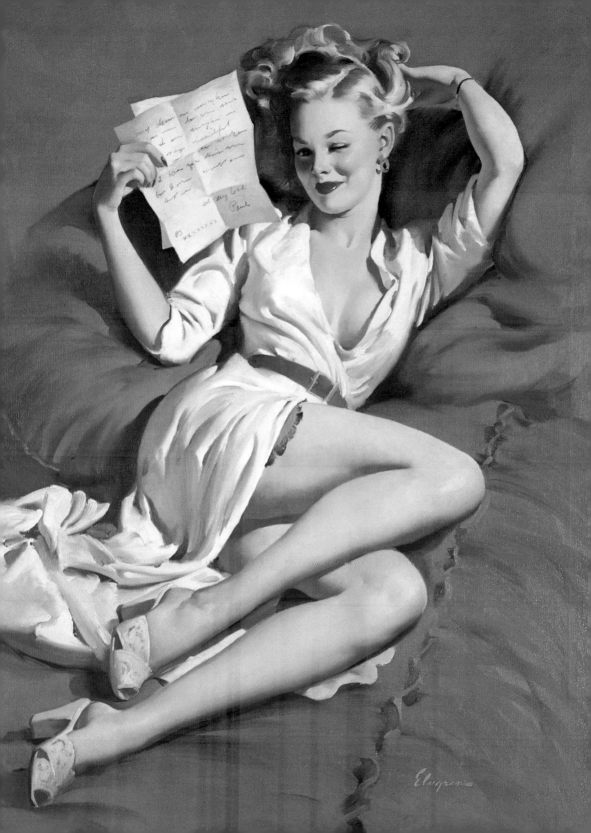

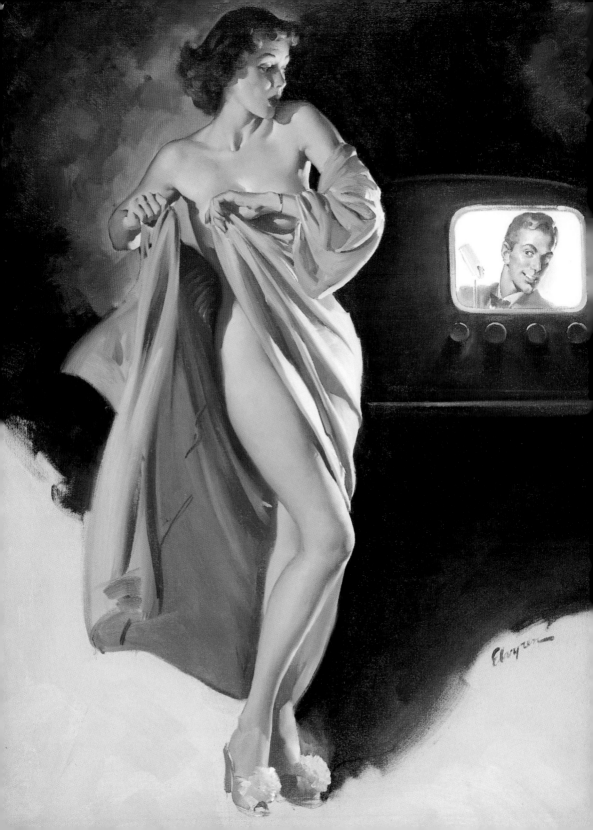

43. WEEK

10.2004

Monday	18	25	1	8	15
Tuesday	19	26	2	9	16
Wednesday	20	27	3	10	17
Thursday	21	28	4	11	18
Friday	22	29	5	12	19
Saturday	23	30	6	13	20
Sunday	24	31	7	14	21
WEEK	**43**	**44**	**45**	**46**	**47**

Monday Montag Lundi Lunes Lunedì Segunda-feira Maandag 月

18

Tuesday Dienstag Mardi Martes Martedì Terça-feira Dinsdag 火

19

Wednesday Mittwoch Mercredi Miércoles Mercoledì Quarta-feira Woensdag 水

◑

20

Thursday Donnerstag Jeudi Jueves Giovedì Quinta-feira Donderdag 木

21

Friday Freitag Vendredi Viernes Venerdì Sexta-feira Vrijdag 金

22

Saturday Samstag Samedi Sábado Sabato Sábado Zaterdag 土

23

Sunday Sonntag Dimanche Domingo Domenica Domingo Zondag 日

24

44. WEEK

10.2004

Monday	25	1	8	15	22
Tuesday	26	2	9	16	23
Wednesday	27	3	10	17	24
Thursday	28	4	11	18	25
Friday	29	5	12	19	26
Saturday	30	6	13	20	27
Sunday	31	7	14	21	28
WEEK	**44**	**45**	**46**	**47**	**48**

Monday Montag Lundi Lunes Lunedì Segunda-feira Maandag 月

(IRL) Last Monday in October

25

Tuesday Dienstag Mardi Martes Martedì Terça-feira Dinsdag 火

(A) Nationalfeiertag

26

Wednesday Mittwoch Mercredi Miércoles Mercoledì Quarta-feira Woensdag 水

27

Thursday Donnerstag Jeudi Jueves Giovedì Quinta-feira Donderdag 木

○

28

Friday Freitag Vendredi Viernes Venerdì Sexta-feira Vrijdag 金

29

Saturday Samstag Samedi Sábado Sabato Sábado Zaterdag 土

30

Sunday Sonntag Dimanche Domingo Domenica Domingo Zondag 日

(D) Reformationstag (teilweise)

31

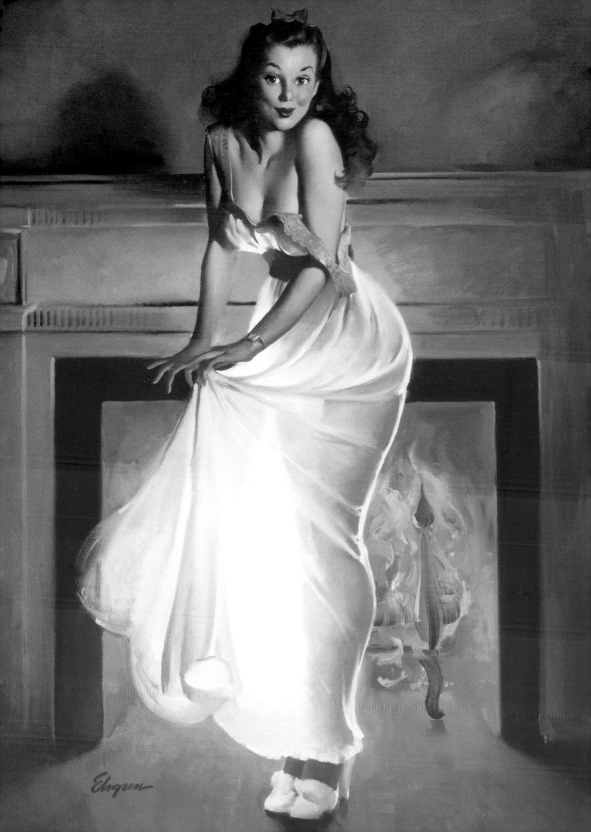

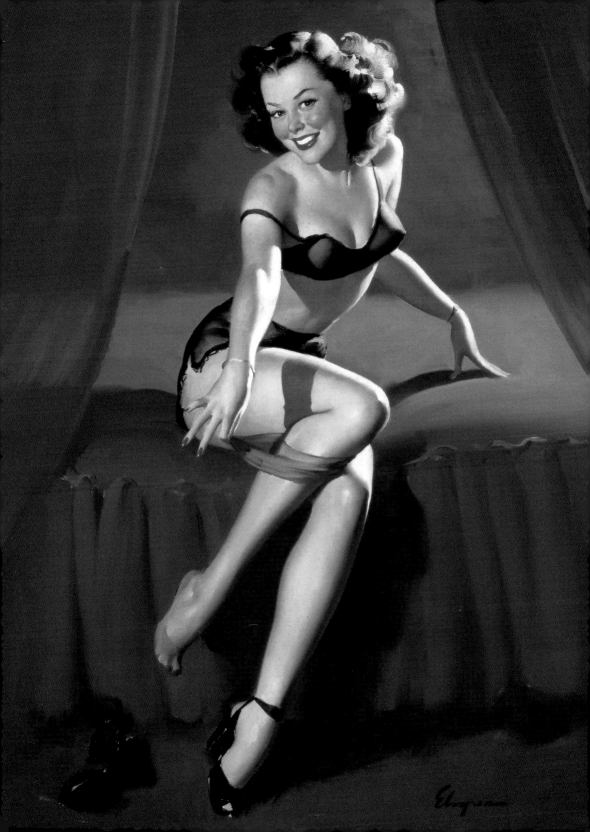

45. WEEK

11.2004

Monday	1	8	15	22	29
Tuesday	2	9	16	23	30
Wednesday	3	10	17	24	1
Thursday	4	11	18	25	2
Friday	5	12	19	26	3
Saturday	6	13	20	27	4
Sunday	7	14	21	28	5
WEEK	**45**	**46**	**47**	**48**	**49**

Monday Montag Lundi Lunes Lunedì Segunda-feira Maandag 月

Ⓓ Allerheiligen (teilweise)

Ⓕ Ⓐ Ⓔ Ⓘ Ⓟ

Toussaint | Allerheiligen | Todos los
Santos | Ognissanti | Todos os Santos

1

Tuesday Dienstag Mardi Martes Martedì Terça-feira Dinsdag 火

2

Wednesday Mittwoch Mercredi Miércoles Mercoledì Quarta-feira Woensdag 水

Ⓙ Culture Day

3

Thursday Donnerstag Jeudi Jueves Giovedì Quinta-feira Donderdag 木

4

Friday Freitag Vendredi Viernes Venerdì Sexta-feira Vrijdag 金

5

Saturday Samstag Samedi Sábado Sabato Sábado Zaterdag 土

6

Sunday Sonntag Dimanche Domingo Domenica Domingo Zondag 日

7

46. WEEK

11.2004

Monday	8	15	22	29	6
Tuesday	9	16	23	30	7
Wednesday	10	17	24	1	8
Thursday	11	18	25	2	9
Friday	12	19	26	3	10
Saturday	13	20	27	4	11
Sunday	14	21	28	5	12
WEEK	46	47	48	49	50

Monday Montag Lundi Lunes Lunedì Segunda-feira Maandag 月

8

Tuesday Dienstag Mardi Martes Martedì Terça-feira Dinsdag 火

9

Wednesday Mittwoch Mercredi Miércoles Mercoledì Quarta-feira Woensdag 水

10

Thursday Donnerstag Jeudi Jueves Giovedì Quinta-feira Donderdag 木

11

(USA) Veterans' Day
(CDN) Remembrance Day | Jour du Souvenir
(F) Armistice 1918

Friday Freitag Vendredi Viernes Venerdì Sexta-feira Vrijdag 金
●

12

Saturday Samstag Samedi Sábado Sabato Sábado Zaterdag 土

13

Sunday Sonntag Dimanche Domingo Domenica Domingo Zondag 日

14

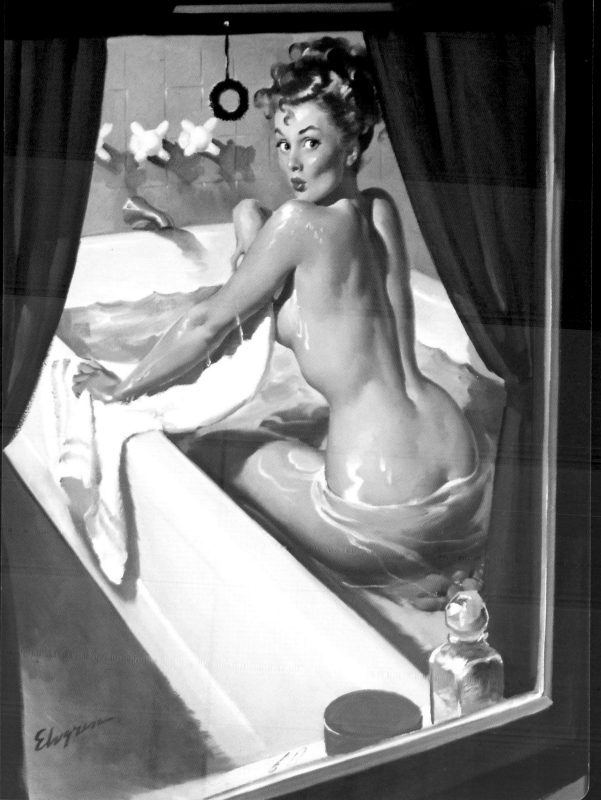

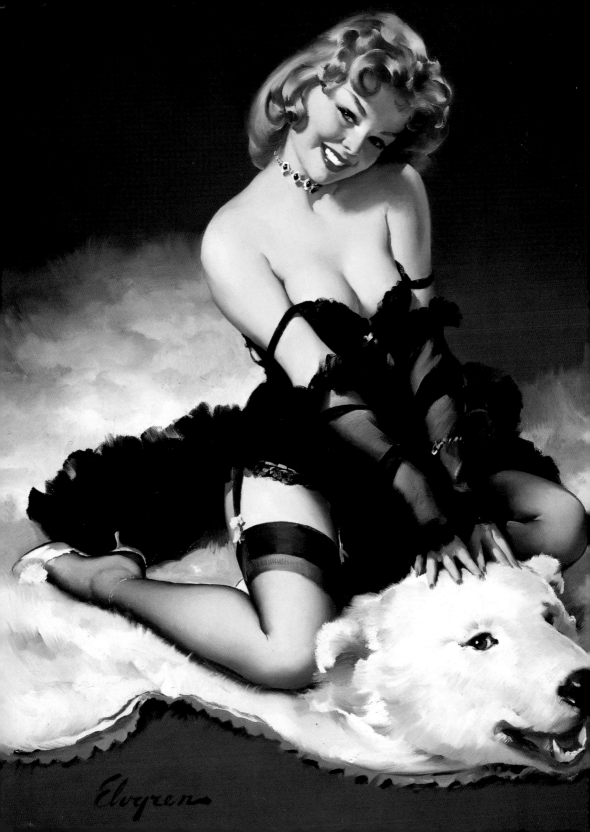

47. WEEK

11.2004

Monday	15	22	29	6	13
Tuesday	16	23	30	7	14
Wednesday	17	24	1	8	15
Thursday	18	25	2	9	16
Friday	19	26	3	10	17
Saturday	20	27	4	11	18
Sunday	21	28	5	12	19
WEEK	**47**	**48**	**49**	**50**	**51**

Monday Montag Lundi Lunes Lunedì Segunda-feira Maandag 月

15

Tuesday Dienstag Mardi Martes Martedì Terça-feira Dinsdag 火

16

Wednesday Mittwoch Mercredi Miércoles Mercoledì Quarta-feira Woensdag 水

Ⓓ Buß- und Bettag (teilweise)

17

Thursday Donnerstag Jeudi Jueves Giovedì Quinta-feira Donderdag 木

18

Friday Freitag Vendredi Viernes Venerdì Sexta-feira Vrijdag 金

19

Saturday Samstag Samedi Sábado Sabato Sábado Zaterdag 土

20

Sunday Sonntag Dimanche Domingo Domenica Domingo Zondag 日

21

48. WEEK

11.2004

Monday Montag Lundi Lunes Lunedì Segunda-feira Maandag 月

22

Tuesday Dienstag Mardi Martes Martedì Terça-feira Dinsdag 火

Ⓙ Labor-Thanksgiving Day

23

Wednesday Mittwoch Mercredi Miércoles Mercoledì Quarta-feira Woensdag 水

24

Thursday Donnerstag Jeudi Jueves Giovedì Quinta-feira Donderdag 木

ⓊⓈⒶ Thanksgiving Day

25

Friday Freitag Vendredi Viernes Venerdì Sexta-feira Vrijdag 金

○

26

Saturday Samstag Samedi Sábado Sabato Sábado Zaterdag 土

27

Sunday Sonntag Dimanche Domingo Domenica Domingo Zondag 日

28

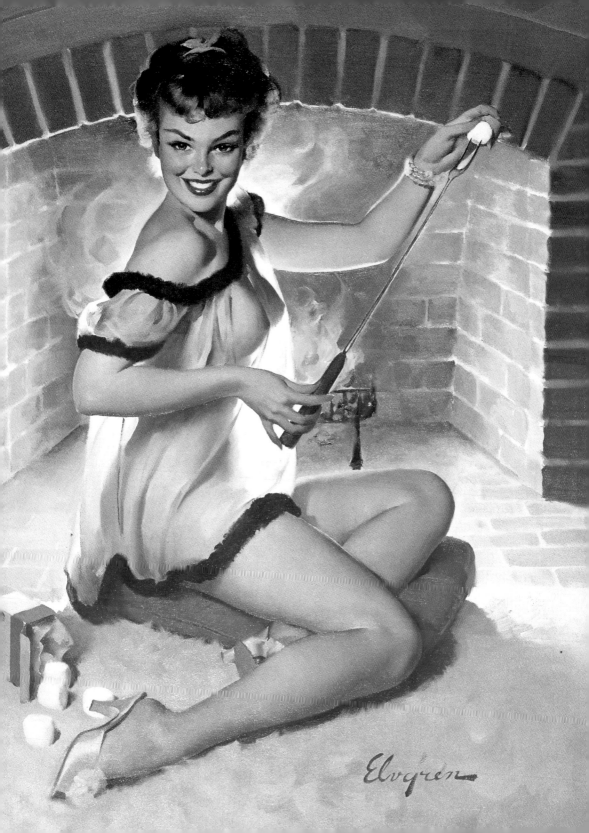

Elvgren

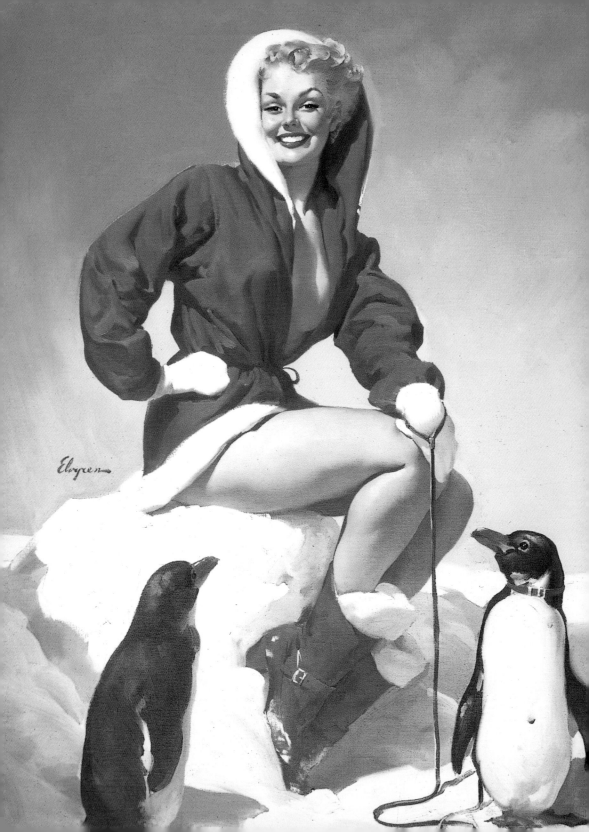

49. ■ WEEK

11|12.2004

Monday	29	6	13	20	27
Tuesday	30	7	14	21	28
Wednesday	1	8	15	22	29
Thursday	2	9	16	23	30
Friday	3	10	17	24	31
Saturday	4	11	18	25	1
Sunday	5	12	19	26	2
WEEK	**49**	**50**	**51**	**52**	**53**

Monday Montag Lundi Lunes Lunedî Segunda-feira Maandag 月

29

Tuesday Dienstag Mardi Martes Martedî Terça-feira Dinsdag 火

30

Wednesday Mittwoch Mercredi Miércoles Mercoledî Quarta-feira Woensdag 水

Ⓟ Dia da Restauração

1

Thursday Donnerstag Jeudi Jueves Giovedî Quinta-feira Donderdag 木

2

Friday Freitag Vendredi Viernes Venerdî Sexta-feira Vrijdag 金

3

Saturday Samstag Samedi Sábado Sabato Sábado Zaterdag 土

4

Sunday Sonntag Dimanche Domingo Domenica Domingo Zondag 日

◗

5

50. WEEK

12.2004

Monday	6	13	20	27	3
Tuesday	7	14	21	28	4
Wednesday	8	15	22	29	5
Thursday	9	16	23	30	6
Friday	10	17	24	31	7
Saturday	11	18	25	1	8
Sunday	12	19	26	2	9
WEEK	**50**	**51**	**52**	**53**	**1**

Monday Montag Lundi Lunes Lunedì Segunda-feira Maandag 月

(E) Día de la Constitución

6

Tuesday Dienstag Mardi Martes Martedì Terça-feira Dinsdag 火

7

Wednesday Mittwoch Mercredi Miércoles Mercoledì Quarta-feira Woensdag 水

(A) (E) (I) (P)
Mariä Empfängnis | Inmaculada
Concepción | Immacolata Concezione |
Imaculada Conceição
(IL) Hanukkah

8

Thursday Donnerstag Jeudi Jueves Giovedì Quinta-feira Donderdag 木

9

Friday Freitag Vendredi Viernes Venerdì Sexta-feira Vrijdag 金

10

Saturday Samstag Samedi Sábado Sabato Sábado Zaterdag 土

11

Sunday Sonntag Dimanche Domingo Domenica Domingo Zondag 日

12

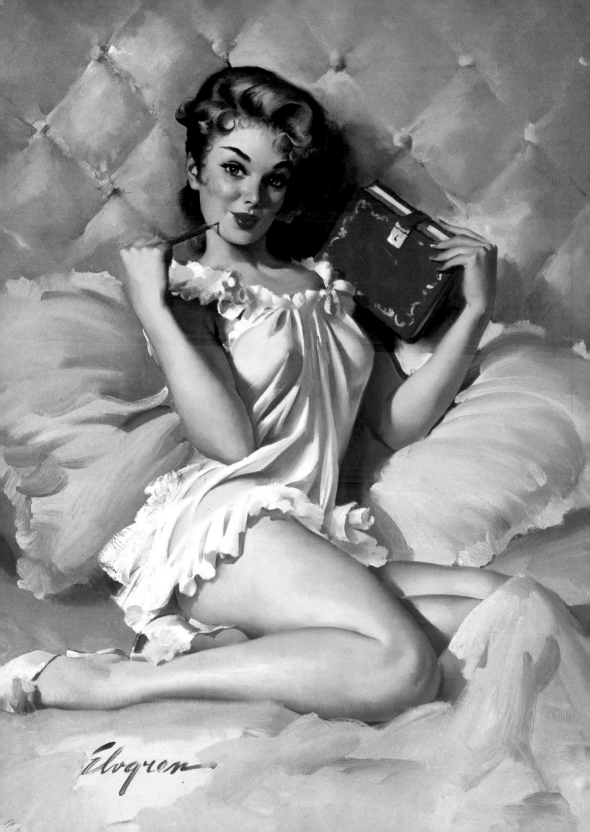

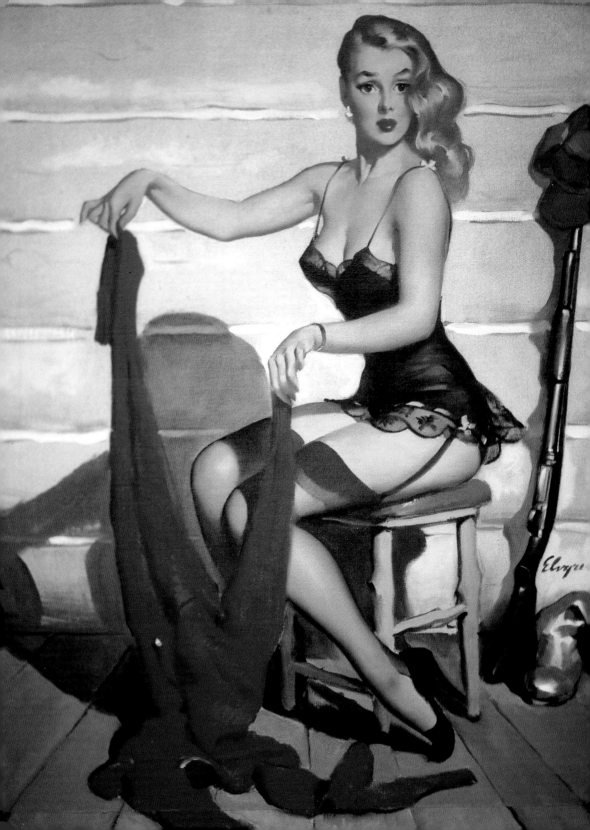

51. WEEK

12.2004

Monday	13	20	27	3	10
Tuesday	14	21	28	4	11
Wednesday	15	22	29	5	12
Thursday	16	23	30	6	13
Friday	17	24	31	7	14
Saturday	18	25	1	8	15
Sunday	19	26	2	9	16
WEEK	**51**	**52**	**53**	**1**	**2**

Monday Montag Lundi Lunes Lunedì Segunda-feira Maandag 月

13

Tuesday Dienstag Mardi Martes Martedì Terça-feira Dinsdag 火

14

Wednesday Mittwoch Mercredi Miércoles Mercoledì Quarta-feira Woensdag 水

15

Thursday Donnerstag Jeudi Jueves Giovedì Quinta-feira Donderdag 木

16

Friday Freitag Vendredi Viernes Venerdì Sexta-feira Vrijdag 金

17

Saturday Samstag Samedi Sábado Sabato Sábado Zaterdag 土

◑

18

Sunday Sonntag Dimanche Domingo Domenica Domingo Zondag 日

19

52. WEEK

12.2004

Monday Montag Lundi Lunes Lunedì Segunda-feira Maandag 月

20

Tuesday Dienstag Mardi Martes Martedì Terça-feira Dinsdag 火

21

Wednesday Mittwoch Mercredi Miércoles Mercoledì Quarta-feira Woensdag 水

22

Thursday Donnerstag Jeudi Jueves Giovedì Quinta-feira Donderdag 木

(J) Emperor's Birthday

23

Friday Freitag Vendredi Viernes Venerdì Sexta-feira Vrijdag 金

24

Saturday Samstag Samedi Sábado Sabato Sábado Zaterdag 土

(USA) (UK) (IRL) (K) (CDN) (F) (D) (A) (CH)
(NL) (E) (I) (P)
Christmas Day | Noël | 1. Weihnachtstag |
Weihnachten | 1e Kerstdag | Natividad
del Señor | Natale | Dia de Natal

25

Sunday Sonntag Dimanche Domingo Domenica Domingo Zondag 日

○

(UK) (IRL) (CDN) (D) (A) (CH) (NL) (I)
Boxing Day | Saint Stephen's Day |
Lendemain de Noël | 2. Weihnachtstag |
Stefanstag | S. Etienne | 2e Kerstdag |
S. Stefano

26

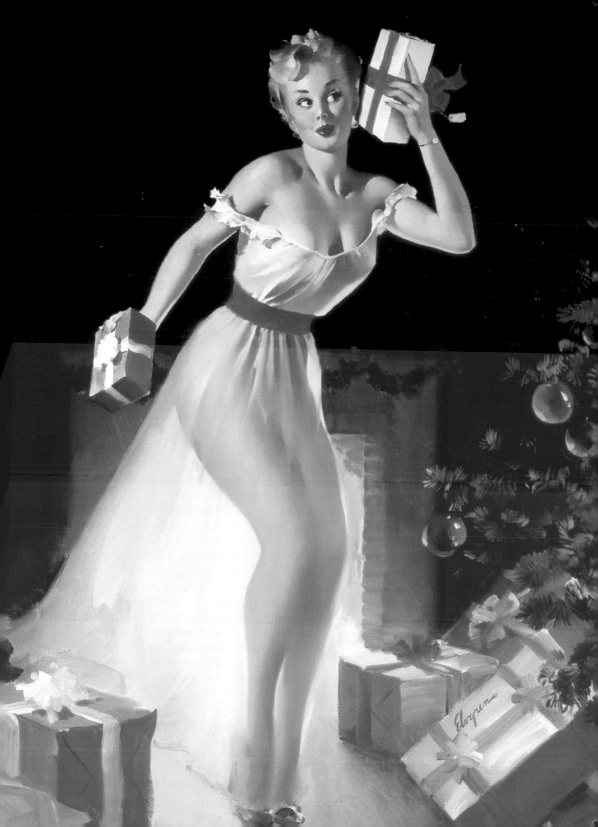

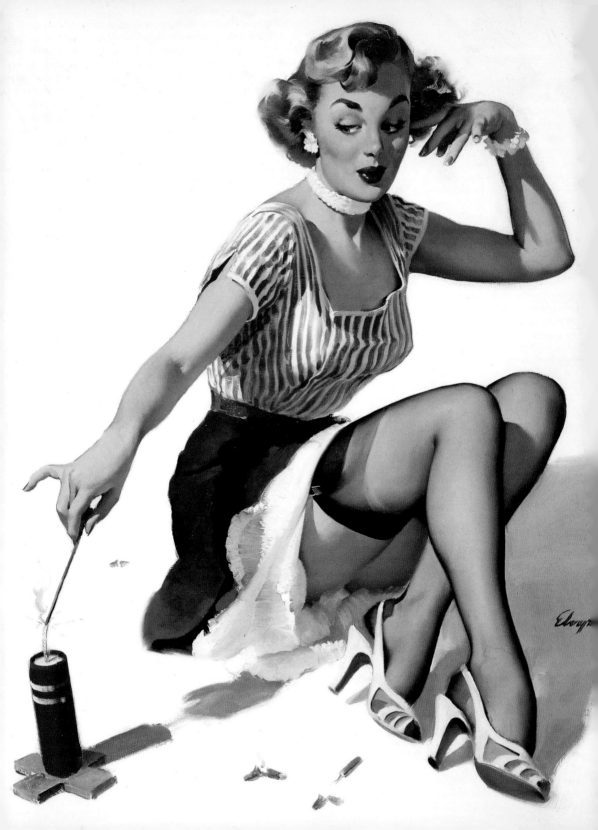

53. WEEK

12.2004 | 01.2005

Monday	27	3	10	17	24
Tuesday	28	4	11	18	25
Wednesday	29	5	12	19	26
Thursday	30	6	13	20	27
Friday	31	7	14	21	28
Saturday	1	8	15	22	29
Sunday	2	9	16	23	30
WEEK	**53**	**1**	**2**	**3**	**4**

Monday Montag Lundi Lunes Lunedì Segunda-feira Maandag 月

(UK) Public Holiday

27

Tuesday Dienstag Mardi Martes Martedì Terça-feira Dinsdag 火

(UK) Public Holiday

28

Wednesday Mittwoch Mercredi Miércoles Mercoledì Quarta-feira Woensdag 水

29

Thursday Donnerstag Jeudi Jueves Giovedì Quinta-feira Donderdag 木

30

Friday Freitag Vendredi Viernes Venerdì Sexta-feira Vrijdag 金

31

Saturday Samstag Samedi Sábado Sabato Sábado Zaterdag 土

New Year's Day | Jour de l'An | Neujahr |
Nieuwjaarsdag | Nieuwjaar | Nouvel An |
Capodanno

1

Sunday Sonntag Dimanche Domingo Domenica Domingo Zondag 日

2

PUBLIC HOLIDAS 2004

PUBLIC HOLIDAYS 2004

Ⓐ Österreich
1.1	Neujahr
6.1	Heilige Drei Könige
11.4	Ostersonntag
12.4	Ostermontag
1.5	Maifeiertag
20.5	Christi Himmelfahrt
30.5	Pfingstsonntag
31.5	Pfingstmontag
10.6	Fronleichnam
15.8	Mariä Himmelfahrt
26.10	Nationalfeiertag
1.11	Allerheiligen
8.12	Mariä Empfängnis
25.12	1. Weihnachtstag
26.12	2. Weihnachtstag

ⒶⓊⓈ Australia
1.1	New Year's Day
26.1	Australia Day
09.4	Good Friday
10.4	Easter Saturday
11.4	Easter Sunday
12.4	Easter Monday
25.4	Anzac Day
26.4	Public Holiday
14.6	Queen's Birthday
25.12	Christmas Day
26.12	Boxing Day
27.12	Public Holiday

Ⓑ Belgique | België
1.1	Jour de l'An	Nieuwjaar
11.4	Pâques	Pasen
12.4	Lundi de Pâques	Paasmaandag
1.5	Fête du Travail	Feest van de Arbeid
20.5	Ascension	Onze-Lieve-Heer-Hemelvaart
30.5	Pentecôte	Pinksteren
31.5	Lundi de Pentecôte	Pinkstermaandag
21.7	Fête nationale	Nationale Feestdag
15.8	Assomption	Onze-Lieve-Vrouw-Hemelvaart
1.11	Toussaint	Allerheiligen
2.11	Jour de Morts	Allerzielen
11.11	Armistice	Wapenstilstand
15.11	Fête de la Dynastie	Feest van de Dynastie
25.12	Noël	Kerstmis

ⒷⓇ Brasil
1.1	Ano Novo
24.2	Carnaval
9.4	Sexta-feira da Paixão
11.4	Páscoa
21.4	Tiradentes
1.5	Dia do Trabalho
10.6	Corpus Christi
7.9	Independência do Brasil
12.10	Nossa Senhora Aparecida
2.11	Finados
15.11	Proclamação da República
25.12	Natal

ⒸⒹⓃ Canada
1.1	New Year's Day	Jour de l'An
9.4	Good Friday	Vendredi Saint
11.4	Easter Sunday	Pâques
12.4	Easter Monday	Lundi de Pâques
24.5	Victoria Day	Fête de la Reine
1.7	Canada Day	Fête du Canada
6.9	Labour Day	Fête du Travail
11.10	Thanksgiving Day	Action de Grâces
11.11	Remembrance Day	Jour du Souvenir
25.12	Christmas Day	Noël
26.12	Boxing Day	Lendemain de Noël

ⒸⒽ Schweiz | Suisse | Svizzera
1.1	Neujahr	Nouvel An	Capodanno
9.4	Karfreitag	Vendredi Saint	Venerdì Santo
11.4	Ostern	Pâques	Pasqua
12.4	Ostermontag	Lundi de Pâques	Lunedì dell'Angelo
20.5	Auffahrt	Ascension	Ascensione
30.5	Pfingstsonntag	Pentecôte	Pentecoste
31.5	Pfingstmontag	Lundi de Pentecôte	Lunedì di Pentecoste
1.8	Bundesfeiertag	Fête nationale	Festa nazionale
25.12	Weihnachten	Noël	Natale
26.12	Stefanstag	S. Etienne	S. Stefano

Ⓒⓞ Colombia
1.1	Año Nuevo
12.1	Reyes Magos
22.3	San José
8.4	Jueves Santo
9.4	Viernes Santo
11.4	Pascua
1.5	Día del Trabajo
24.5	Ascención del Señor
14.6	Corpus Christi
21.6	Sagrado Corazón
5.7	San Pedro y San Pablo
20.7	Independencia Nacional
7.8	Batalla de Boyacá
16.8	Asunción de la Virgen
17.10	Día de la Raza
18.10	Public Holiday
1.11	Día de Todos los Santos
11.11	Independencia de Cartagena
8.12	Inmaculada Concepción
25.12	Navidad

Ⓓ Bundesrepublik Deutschland
1.1	Neujahr
6.1	Heilige Drei Könige (teilw.)
9.4	Karfreitag
11.4	Ostersonntag
12.4	Ostermontag
1.5	Maifeiertag
20.5	Christi Himmelfahrt
30.5	Pfingstsonntag
31.5	Pfingstmontag
10.6	Fronleichnam (teilw.)
15.8	Mariä Himmelfahrt (teilw.)
3.10	Tag der Deutschen Einheit
31.10	Reformationstag (teilw.)
1.11	Allerheiligen (teilw.)
17.11	Buß- und Bettag (teilw.)
25.12	1. Weihnachtstag
26.12	2. Weihnachtstag

Ⓓⓚ Danmark
1.1	Nytår
8.4	Skærtorsdag
9.4	Langfredag
11.4	Påske
12.4	Påske
7.5	St. Bededag
20.5	Kristi himmelfartsdag
30.5	Pinse
31.5	2. Pinsedag
6.6	Grundlovsdag
25.12	Juledag
26.12	St. Stefansdag

Ⓔ España | Catalunya
1.1	Año Nuevo	Cap d'Any
6.1	Reyes	Reis
9.4	Viernes Santo	Divendres Sant
11.4	Pascua	Diumenge de Pascua
1.5	Fiesta del Trabajo	Festa del Treball
15.8	Asunción de la Virgen	L'Assumpció
12.10	Fiesta Nacional	Festa Nacional d'Espanya
1.11	Todos los Santos	Tots Sants
6.12	Día de la Constitución	Dia de la Constitució
8.12	Inmaculada Concepción	La Immaculada
25.12	Natividad del Señor	Nadal

Ⓕ France
1.1	Jour de l'An
11.4	Pâques
12.4	Lundi de Pâques
1.5	Fête du Travail
8.5	Fête de la Libération
20.5	Ascension
30.5	Pentecôte
31.5	Lundi de Pentecôte
14.7	Fête Nationale
15.8	Assomption
1.11	Toussaint
11.11	Armistice 1918
25.12	Noël

ⒻⒾⓝ Suomi
1.1	Uudenvuodenpäivä
6.1	Loppiainen
9.4	Pitkäperjantai
11.4	Pääsiäispäivä
12.4	2. Pääsiäispäivä
1.5	Vapunpäivä
20.5	Helatorstai
30.5	Helluntaipäivä
26.6	Juhannuspäivä
6.11	Pyhäinpäivä
6.12	Itsenäisyyspäivä
25.12	Joulupäivä
26.12	Tapaninpäivä

Ⓘ Italia
1.1	Capodanno
6.1	Epifania
11.4	Pasqua
12.4	Lunedì dell' Angelo
25.4	Liberazione
1.5	Festa del Lavoro
2.6	Festa della Repubblica
15.8	Assunzione
1.11	Ognissanti
8.12	Immacolata Concezione
25.12	Natale
26.12	S. Stefano

Ⓘⓛ Israel
4.2	Tu B'Shevat
7.3	Purim
6.4	Passover
18.4	Yom Hashoah
26.4	Yom Haatzmaut
26.5	Shavuot
27.7	Tisha B'Av
16.9	Rosh Hashanah
25.9	Yom Kippur
30.10	Succoth
7.10	Sh'mini Atzereth
8.10	Simchat Torah
8.12	Hanukkah

Ireland (IRL)

1.1	New Year's Day
17.3	Saint Patrick's Day
11.4	Easter Sunday
12.4	Easter Monday
3.5	First Monday in May
7.6	First Monday in June
2.8	First Monday in August
25.10	Last Monday in October
25.12	Christmas Day
26.12	Saint Stephen's Day

Japan (J)

1.1	New Year's Day
1.12	Coming-of-Age Day
2.11	Commemoration of the Founding of the Nation
3.20	Vernal Equinox Day
4.29	Greenery Day
5.3	Constitution Day
5.4	Public Holiday
5.5	Children's Day
7.19	Marine Day
9.20	Respect-for-the-Aged Day
9.23	Autumn Equinox Day
10.11	Health-Sports Day
11.3	Culture Day
11.23	Labor-Thanksgiving Day
12.23	Emperor's Birthday

Korea (K)

1.1	New Year's Day
1.22	Lunar New Year's Day
3.1	3-1 Anniversary
4.5	Arbor Day
5.5	Children's Day
5.26	Buddha's Birthday
6.6	Memorial Day
7.17	Constitution Day
8.15	Independence Day
9.28	Thanksgiving Day
10.3	National Foundation Day
10.9	Hangeul Proclamation Day
12.25	Christmas Day

Luxembourg (L)

1.1	Jour de l'An
11.4	Pâques
12.4	Lundi de Pâques
1.5	Fête du Travail
20.5	Ascension
30.5	Pentecôte
31.5	Lundi de Pentecôte
23.6	Fête Nationale
15.8	Assomption
1.11	Toussaint
25.12	Noël
26.12	Lendemain de Noël

México (MEX)

1.1	Año Nuevo
5.2	Aniversario de la Constitución
21.3	Natalicio de Benito Juárez
8.4	Jueves Santo
9.4	Viernes Santo
11.4	Pascua
1.5	Día del Trabajo
16.9	Día de la Independencia
20.11	Aniversario de la Revolución Mexicana
25.12	Navidad

Norge (N)

1.1	Nyttårsdag
4.4	Palmesøndag
8.4	Skjærtorsdag
9.4	Langfredag
11.4	1. påskedag
12.4	2. påskedag
1.5	Offentlig høytidsdag
17.5	Grunnlovsdag
20.5	Kristi himmelfartsdag
30.5	1. pinsedag
31.5	2. pinsedag
25.12	1. juledag
26.12	2. juledag

Nederland (N)

1.1	Nieuwjaarsdag
11.4	1e Paasdag
12.4	2e Paasdag
30.4	Koninginnedag
20.5	Hemelvaartsdag
30.5	1e Pinksterdag
31.5	2e Pinksterdag
25.12	1e Kerstdag
26.12	2e Kerstdag

New Zealand (NZ)

1.1	New Year's Day
2.1	Day after New Year's Day
6.2	Waitangi Day
9.4	Good Friday
11.4	Easter Sunday
12.4	Easter Monday
25.4	Anzac Day
7.6	Queen's Birthday
25.10	Labour Day
25.12	Christmas Day
26.12	Boxing Day
27.12	Public Holiday
28.12	Public Holiday

Portugal (P)

1.1	Ano Novo
9.4	Sexta-feira Santa
11.4	Domingo de Páscoa
25.4	Dia da Liberdade
1.5	Dia do Trabalhador
10.6	Dia Nacional \| Corpo de Deus
15.8	Assunção de Nossa Senhora
5.10	Implantação da República
1.11	Todos os Santos
1.12	Dia da Restauração
8.12	Imaculada Conceição
25.12	Dia de Natal

Argentina (RA)

1.1	Año Nuevo
8.4	Jueves Santo
9.4	Viernes Santo
11.4	Pascua
1.5	Día del Trabajador
25.5	Fundación del Primer Gobierno Nacional
7.6	Recuperación de las Islas Malvinas
20.6	Día de la Bandera
9.7	Día de la Independencia
17.8	Muerte del General San Martín
12.10	Descubrimiento de América
8.12	Inmaculada Concepción de la Virgen María
25.12	Navidad

Chile (RCH)

1.1	Año Nuevo
9.4	Viernes Santo
10.4	Sábado Santo
11.4	Pascua
1.5	Día del Trabajo
21.5	Combate Naval de Iquique
7.6	Corpus Christi
15.8	Asunción de la Virgen
18.9	Fiestas Patrias
19.9	Día del Ejército
11.10	Día de la Hispanidad
1.11	Todos los Santos
8.12	Inmaculada Concepción
25.12	Navidad

Sverige (S)

1.1	Nyårsdagen
6.1	Trettondag jul
9.4	Långfredagen
11.4	Påskdagen
12.4	Annandag påsk
1.5	Första maj
20.5	Kristi himmelsfärds dag
30.5	Pingstdagen
31.5	Annandag pingst
26.6	Midsommardagen
6.11	Alla helgons dag
25.12	Juldagen
26.12	Annandag jul

United Kingdom (UK)

1.1	New Year's Day
2.1	Bank Holiday (Scotland only)
17.3	Saint Patrick's Day (Northern Ireland only)
9.4	Good Friday
11.4	Easter Sunday
12.4	Easter Monday (except Scotland)
3.5	May Bank Holiday
31.5	Spring Bank Holiday
12.7	Battle of the Boyne Day (Northern Ireland only)
2.8	Summer Bank Holiday (Scotland only)
30.8	Summer Bank Holiday (except Scotland)
25.12	Christmas Day
26.12	Boxing Day
27.12	Public Holiday
28.12	Public Holiday

United States (USA)

1.1	New Year's Day
19.1	Martin Luther King Day
16.2	Presidents' Day
11.4	Easter Sunday
31.5	Memorial Day
4.7	Independence Day
6.9	Labor Day
11.10	Columbus Day
11.11	Veterans' Day
25.11	Thanksgiving Day
25.12	Christmas Day

South Africa (ZA)

1.1	New Year's Day
21.3	Human Rights Day
22.3	Public Holiday
9.4	Good Friday
11.4	Easter Sunday
12.4	Family Day
27.4	Freedom Day
1.5	Workers' Day
3.5	Public Holiday
16.6	Youth Day
9.8	National Women's Day
24.9	Heritage Day
16.12	Day of Reconciliation
25.12	Christmas Day
26.12	Day of Goodwill

Some international holidays may be subject to change.

YEAR PLANNER

JANUARY

1	Sa
2	Su
WEEK 1	
3	Mo ◐
4	Tu
5	We
6	Th
7	Fr
8	Sa
9	Su
WEEK 2	
10	Mo ●
11	Tu
12	We
13	Th
14	Fr
15	Sa
16	Su
WEEK 3	
17	Mo ◑
18	Tu
19	We
20	Th
21	Fr
22	Sa
23	Su
WEEK 4	
24	Mo
25	Tu ○
26	We
27	Th
28	Fr
29	Sa
30	Su
WEEK 5	
31	Mo

FEBRUARY

1	Tu
2	We ◐
3	Th
4	Fr
5	Sa
6	Su
WEEK 6	
7	Mo
8	Tu ●
9	We
10	Th
11	Fr
12	Sa
13	Su
WEEK 7	
14	Mo
15	Tu
16	We ◑
17	Th
18	Fr
19	Sa
20	Su
WEEK 8	
21	Mo
22	Tu
23	We
24	Th ○
25	Fr
26	Sa
27	Su
WEEK 9	
28	Mo

MARCH

1	Tu
2	We
3	Th ◐
4	Fr
5	Sa
6	Su
WEEK 10	
7	Mo
8	Tu
9	We
10	Th ●
11	Fr
12	Sa
13	Su
WEEK 11	
14	Mo
15	Tu
16	We
17	Th ◑
18	Fr
19	Sa
20	Su
WEEK 12	
21	Mo
22	Tu
23	We
24	Th
25	Fr ○
26	Sa
27	Su
WEEK 13	
28	Mo
29	Tu
30	We
31	Th

APRIL

1	Fr
2	Sa ◐
3	Su
WEEK 14	
4	Mo
5	Tu
6	We
7	Th
8	Fr ●
9	Sa
10	Su
WEEK 15	
11	Mo
12	Tu
13	We
14	Th
15	Fr
16	Sa ◑
17	Su
WEEK 16	
18	Mo
19	Tu
20	We
21	Th
22	Fr
23	Sa
24	Su ○
WEEK 17	
25	Mo
26	Tu
27	We
28	Th
29	Fr
30	Sa

05-08.2005

MAY	JUNE	JULY	AUGUST
1 Su ◑	1 We	1 Fr	**WEEK 31**
WEEK 18	2 Th	2 Sa	1 Mo
2 Mo	3 Fr	3 Su	2 Tu
3 Tu	4 Sa	**WEEK 27**	3 We
4 We	5 Su	4 Mo	4 Th
5 Th	**WEEK 23**	5 Tu	5 Fr ●
6 Fr	6 Mo ●	6 We ●	6 Sa
7 Sa	7 Tu	7 Th	7 Su
8 Su ●	8 We	8 Fr	**WEEK 32**
WEEK 19	9 Th	9 Sa	8 Mo
9 Mo	10 Fr	10 Su	9 Tu
10 Tu	11 Sa	**WEEK 28**	10 We
11 We	12 Su	11 Mo	11 Th
12 Th	**WEEK 24**	12 Tu	12 Fr
13 Fr	13 Mo	13 We	13 Sa ◐
14 Sa	14 Tu	14 Th ◐	14 Su
15 Su	15 We ◐	15 Fr	**WEEK 33**
WEEK 20	16 Th	16 Sa	15 Mo
16 Mo ◐	17 Fr	17 Su	16 Tu
17 Tu	18 Sa	**WEEK 29**	17 We
18 We	19 Su	18 Mo	18 Th
19 Th	**WEEK 25**	19 Tu	19 Fr ○
20 Fr	20 Mo	20 We	20 Sa
21 Sa	21 Tu	21 Th ○	21 Su
22 Su	22 We ○	22 Fr	**WEEK 34**
WEEK 21	23 Th	23 Sa	22 Mo
23 Mo ○	24 Fr	24 Su	23 Tu
24 Tu	25 Sa	**WEEK 30**	24 We
25 We	26 Su	25 Mo	25 Th
26 Th	**WEEK 26**	26 Tu	26 Fr ◑
27 Fr	27 Mo	27 We	27 Sa
28 Sa	28 Tu ◑	28 Th ◑	28 Su
29 Su	29 We	29 Fr	**WEEK 35**
WEEK 22	30 Th	30 Sa	29 Mo
30 Mo ◑		31 Su	30 Tu
31 Tu			31 We

09–12.2005

SEPTEMBER

1 Th
2 Fr
3 Sa ●
4 Su
WEEK 36
5 Mo
6 Tu
7 We
8 Th
9 Fr
10 Sa
11 Su ◐
WEEK 37
12 Mo
13 Tu
14 We
15 Th
16 Fr
17 Sa
18 Su ○
WEEK 38
19 Mo
20 Tu
21 We
22 Th
23 Fr
24 Sa
25 Su ◐
WEEK 39
26 Mo
27 Tu
28 We
29 Th
30 Fr

OCTOBER

1 Sa
2 Su
WEEK 40
3 Mo ●
4 Tu
5 We
6 Th
7 Fr
8 Sa
9 Su
WEEK 41
10 Mo ◐
11 Tu
12 We
13 Th
14 Fr
15 Sa
16 Su
WEEK 42
17 Mo ○
18 Tu
19 We
20 Th
21 Fr
22 Sa
23 Su
WEEK 43
24 Mo
25 Tu ◐
26 We
27 Th
28 Fr
29 Sa
30 Su
WEEK 44
31 Mo

NOVEMBER

1 Tu
2 We ●
3 Th
4 Fr
5 Sa
6 Su
WEEK 45
7 Mo
8 Tu
9 We ◐
10 Th
11 Fr
12 Sa
13 Su
WEEK 46
14 Mo
15 Tu
16 We ○
17 Th
18 Fr
19 Sa
20 Su
WEEK 47
21 Mo
22 Tu
23 We ◐
24 Th
25 Fr
26 Sa
27 Su
WEEK 48
28 Mo
29 Tu
30 We

DECEMBER

1 Th ●
2 Fr
3 Sa
4 Su
WEEK 49
5 Mo
6 Tu
7 We
8 Th ◐
9 Fr
10 Sa
11 Su
WEEK 50
12 Mo
13 Tu
14 We
15 Th ○
16 Fr
17 Sa
18 Su
WEEK 51
19 Mo
20 Tu
21 We
22 Th
23 Fr ◐
24 Sa
25 Su
WEEK 52
26 Mo
27 Tu
28 We
29 Th
30 Fr
31 Sa ●

ADDRESSES AND NOTES